ACKNOWLEDGEMENTS:

THE LENDERS:

Cincinnati Art Museum, Cincinnati, Ohio
City Art Gallery, Manchester, England
The Fitzwilliam Museum, Cambridge, England
Victoria and Albert Museum, London, England
Yale Center for British Art, New Haven, Connecticut

Mr. Julian Spalding, director, City Art Gallery, Manchester
Mr. Julian Treuherz, keeper, City Art Gallery, Manchester
Ms. Sandra Martin, assistant keeper, City Art Gallery, Manchester
Ms. Nicola Walker, paper conservator, City Art Gallery, Manchester
Mr. David McNeff, registrar, City Art Gallery, Manchester
Mr. Duncan Robinson, director, Yale Center for British Art, New Haven, CT
Mr. Patrick Noon, curator, Yale Center for British Art, New Haven, CT
Mr. Timothy Goodhue, registrar, Yale Center for British Art, New Haven, CT
Mr. John Murdoch, deputy keeper, Department of Prints, Drawings, & Photographs and Paintings, Victoria and Albert Museum, London.
Miss Anne Buddle, senior museum assistant, Department of Prints, Drawings, & Photographs and Paintings, Victoria and Albert Museum, London.
Ms. Fredericka Smith, registrar, Victoria and Albert Museum, London.
Professor Michael Jaffé, director, The Fitzwilliam Museum, Cambridge
Mr. David E. Scrase, keeper, Paintings, Drawings, and Prints, The Fitzwilliam Museum, Cambridge

Ms. Jane Munro, assistant keeper, Paintings, Drawings, and Prints, The Fitzwilliam Museum, Cambridge
Ms. Melissa Dalziel, photographic sales officer, The Fitzwilliam Museum, Cambridge
Mr. Millard F. Rogers, Jr., director, Cincinnati Art Museum
Ms. Kristin Spangenberg, curator, Department of Prints, Drawings, and Photographs, Cincinnati Art Museum
Ms. Mary Ellen Goeke, acting registrar, Cincinnati Art Museum
Ms. Alice M. Whelihan, indemnity administrator, Museum Program, National Endowment for the Arts, Washington, D.C.
The National Endowment for the Arts, Museum Program, Indemnification Panel and Council, Washington, D.C.
Mr. Evelyn L. Joll, chairman, managing directors, Thos. Agnew & Sons, Ltd., London, England
Ms. Patricia J. Whitesides, registrar, The Toledo Museum of Art, Toledo, Ohio
Professor Robert K. Wallace, Northern Kentucky University, Highland Heights, Kentucky
Ms. Jean Reis, director, The Corbett Foundation, Cincinnati, Ohio

Mr. Shanes personally acknowledges the assistance of:

Jane Cocking
Jacky Darville
Peter Hodes
Margo Sonnendecker
Professor R.K. Wallace
and especially Edward Yardley, for providing a modified and updated list of provenances for each work incorporating much new material

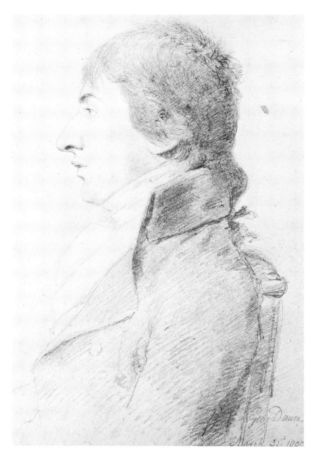

*George Dance, **Portrait of J.M.W. Turner,** signed and dated 31 March 1800; black chalk touched with white and pink on paper, 25.5 x 19.5 cm.; Royal Academy of Arts, London.*

J.M.W. TURNER: THE FOUNDATIONS OF GENIUS

by Eric Shanes

This exhibition has several purposes which are embodied in the various definitions of the word "foundations" that is used in its title. They are, primarily, to look at J.M.W. Turner's work as a landscape watercolorist (but not as a marine artist, for reasons outlined below); to examine the founding of his art in his primary training as an architectural topographer; and to examine the theoretical foundation of his art, the underlying ground or reason upon which he acted and constantly strengthened and enlarged. To this end fifty watercolors from five lending institutions have been gathered together. These drawings will hopefully furnish an adequate cross section of work through which we may be able to gauge these bases and their subsequent reinforcements throughout Turner's overall career as a landscape watercolorist. Naturally, they will also demonstrate the large variety of responses that the artist was capable of achieving in the medium of watercolor itself.

The fact that Turner's lifespan conveniently covered just over three-quarters of a century, from 1775 to 1851, will assist us in our examination. As a result, we can usefully divide his career into three periods: the early work up to 1800 (a significant year in Turner's artistic development); a middle period from 1800 to 1825 (coincidentally a key year in his personal development); and a final period up until the end of his working life in 1850. Although such a division is not intended to be anything more significant than a means of coming to terms with Turner's vast output—for it must be stressed that his was an entirely *unbroken* artistic development—nonetheless such a division will prove helpful for the purposes of this exhibition since the three periods are accurately reflected

J.M.W. Turner:
The Foundations of Genius

by Eric Shanes

The Taft Museum
Cincinnati, Ohio

September 18 - November 2, 1986

Publication of this catalogue has been made possible in part by a grant from the Corbett Foundation, Cincinnati, Ohio, and through the generous cooperation of The Hennegan Co. printers, Cincinnati, Ohio. This exhibition is supported by an indemnity from the Federal Council on the Arts and Humanities.

INTRODUCTION

J.M.W. TURNER: THE FOUNDATIONS OF GENIUS was conceived for the purpose of showing his ten watercolors in the Taft Museum collection within a larger survey of his career. The specific context of the exhibition which is the sources of his training as a watercolorist and the emergence of his artistic philosophy was suggested by Eric Shanes at the time of his lecture engagement at the museum in April 1984. Shanes' collaboration in this project has been fundamental for as guest curator he has developed its thesis, secured the loans of critical examples, authored the catalogue essay and accompanying entries, and given guidance and inspiration to the many facets of our presentation. All of us who cherish the Turners at the Taft are gratefully indebted to him for his energetic scholarship.

Ancillary to the principal purpose of our exhibition has been our wish to show our watercolors together—one last time—before we institute a policy of selective rotation of them as a conservation procedure. Eight of the ten have now been given conservation treatment at the Intermuseum Conservation Association laboratory in Oberlin, Ohio, by paper conservator Gina McKay. This work was supported in part by a grant from the Museums Program of the National Endowment for the Arts.

We are frequently asked about the formation of the Taft Art Collection and it is our intention to publish a full discussion of their patronage and connoisseurship in our forthcoming catalogue. Like the majority of their paintings all but one of the Turners purchased by Charles Phelps and Anna Sinton Taft came from the firm of Scott and Fowles in New York City. According to our records the earliest purchase was the delightful drawing of *The Great Whale* acquired in 1903; other drawings and the oil paintings *The Trout Stream* and *The Rape of Europa* were bought between 1904 and 1907. *Old London Bridge,* which is no longer firmly attributed to Turner, entered the collection in 1910 from a different source. Our tenth watercolor by Turner came from the collection of their daughter, Jane Taft Ingalls, and it was bequeathed to us in 1962. During the Tafts' lifetimes their Turner watercolors were displayed in Mrs. Taft's sitting room. Two of the oils were to be found in the Red Room where they were accorded prominent display among the most admired objects in the collection. No doubt this British artist held great prominence for Mr. and Mrs. Taft. He would have reminded them both of their fondness for literature and for travel as Mr. Shanes' essay will tell us.

Mr. and Mrs. J. Ralph Corbett have emulated the Tafts in their support of the visual and performing arts in Cincinnati and it is with great pride that we thank the Corbett Foundation for its support of this exhibition and its catalogue. Printing of this catalogue has been generously assisted by The Hennegan Company, to whom we also extend our gratitude. As director of the Taft Museum, my personal thanks go to the Taft Museum Committee for endorsing this project wholeheartedly and to our outstanding staff whose dedication and commitment shines through once again.

On behalf of everyone associated with the Taft Museum including the people of Cincinnati to whom the Tafts gave their collection, I wish to thank the lending institutions and their representatives for without their cooperation this exhibition would not be possible.

Ruth K. Meyer
Director

by the proportion of works on show: just over a third are early-period drawings (a percentage that increases if the watercolors owned by the Taft Museum which are also included in the exhibition are omitted from our count); another third consists of middle-period works; and just less than a further third comprises final-period watercolors. By this means it is hoped to achieve an equal balance of watercolors in terms of the period to which they belong. This balance of work is often neglected in exhibitions of Turner watercolors because of the desire that is frequently encountered to rush through the works of the artist's emergent phase in order to arrive more quickly at the fruits of his maturity. Such an omission is not altogether surprising, for it is in his mature works that the painter so clearly seems to prefigure modern sensibility with regards to landscape and art. Yet such an approach is not entirely fair to ourselves, for in Turner's early works there are a plenitude of riches, some of which it is the hope of this exhibition to reveal more fully to the Cincinnati public.

Cincinnati is, of course, comparatively quite rich in Turners, the Taft Museum owning thirteen works (including two oil paintings) and the Cincinnati Art Museum an additional watercolor. Of the two Taft oils, one, *Europa and the Bull*, is undeniably a major masterpiece which has recently been cleaned and is on display in the Museum. But all of the Cincinnati works are middle- to late-period pictures—the earliest dates from 1809 when Turner was thirty-four years old—and thus there has been little local opportunity to evaluate the early Turner at firsthand. Such an evaluation is therefore one of the prime purposes of this show.

Turner is one of that select band of artists—Van Gogh and Cézanne are others who immediately come to mind—whose work demonstrates a quite startling sense of progression. Their early productions and their final pictures might superficially appear to have emanated from different artists, so dissimilar in visual language do

they appear at first glance. For example, if we compare one of Turner's early watercolors, such as the *Interior of King John's Palace, Eltham,* of around 1793 (plate #1), with one of his final-period works, such as the watercolor of *Heidelberg: Sunset,* dating from about 1841 (plate #55), it might prove difficult to perceive that they have issued from the same hand, so far has Turner progressed in the interim. Yet with a single exception each of the qualities present in the later work can be seen to be already evident to some degree in the earlier one: the luminosity, the intense awareness of space and scale, the grasp of architectonic values and relationships, the total comprehension of architectural forms and character, and the full exploration of the medium employed, both for denotive and expressive effects. The only quality which seems immediately evident in the later and not the earlier work is the intensity of color. However, without relying too much upon hindsight it is possible to detect the latency of Turner's awareness of color in the tonal ranges and varieties of the early picture, if admittedly not its full deployment. But well before Turner had reached complete maturity such a powerful sense of color had begun to assert itself, as we can see, for example, in *Warkworth Castle, Northumberland—thunder storm approaching at sun-set* of 1799 (plate #19). Here, too, we may clearly detect the emergence of what would come to fruition later in Turner's art.

What were the foundations of Turner's genius, and how did they receive continual reinforcement? Unless it is believed that genius is entirely innate, and that it does not in part arise from an inextricable interplay with the culture in which it operates, receiving constant support and sustenance from that surround, then it is possible to consider Turner's artistic beginnings as the necessary "foundation" or primary condition upon which his future development depended. But it might prove helpful to our examination if we survey the painter's life and work very briefly before going on to discuss aspects of

his early art and how certain apparent preoccupations arose and developed throughout the rest of his career. Given the primary aims of this exhibition, in such a survey we will therefore pay slightly more detailed attention to Turner's formative years than we shall to those of his maturity. Through doing so we may subsequently find it easier to discern how Turner's end lay in his beginnings and to see wherein were embedded the foundations of his genius.

Joseph Mallord William Turner was born on 23 April 1775 in the Covent Garden area of London, the son of a wig-maker and barber. When he was about six his elder sister died at the age of nine, and this event appears to have contributed toward the mental breakdown of Turner's mother who died in a mental hospital in 1804. Probably as a result of this unsettled family environment Turner was sent to stay with relatives in Brentford, the county town of Middlesex, to the west of London. Later he may have briefly attended school in Margate, a seaside town on the Thames estuary. His first artistic efforts date from 1787 when he was eleven, consisting of colorings of engravings and copies from those prints. Sometime in the next few years he seems to have started working for the architectural topographer, Thomas Malton (1748-1804), and we know from evidence supplied by Turner himself that he certainly went out drawing with Malton around 1789. During the late 1780s he may also have worked briefly in Paul Sandby's drawing school in St. Martin's Lane as well as for the architects and architectural draftsmen Thomas Hardwick and William Porden, by whom he was employed to color architectural elevations. A charming, if apocryphal, story accounts for Turner's dismissal from Porden's employ as resulting from the young artist's insistence upon coloring window panes with reflections upon the glass instead of simply representing them as dark spaces, an effect that Porden preferred.

On 11 December 1789, after spending a term as a probationer, the fourteen-year-old Turner was admitted as a student to the Royal Academy Schools after an interview conducted by the President of the Academy, Sir Joshua Reynolds. And in 1790, at the age of fifteen, Turner exhibited at the Royal Academy Annual Exhibition for the very first time, submitting a watercolor of *The Archbishop's Palace, Lambeth* (Indianapolis Museum of Art; ill. 1). Thereafter he exhibited regularly at the Academy for the rest of his working life, sending in one or a group of oils and watercolors almost annually. After 1830, however, he no longer displayed his watercolors there.

Turner was particularly active in the life-drawing class at the Academy during the winter of 1792-93, progressing there after spending some two and a half years of intermittent study in the antique-cast school. By then he had assimilated the influence of Thomas Malton and augmented it through further important assimilations.

*1 J.M.W. Turner, **The Archbishop's Palace, Lambeth**, R.A., 1790; pencil and watercolor on paper, 26.3 x 37.8 cm.; The Indianapolis Museum of Art, gift in memory of Dr. and Mrs. Hugo O. Pantzer.*

Among these influences was that of Michael Angelo Rooker (1746-1801), a topographical watercolorist from whom Turner clearly learned to delineate the surfaces of architecture with a far greater sense of variety than existed in Malton. He also gained from Rooker an even more heightened awareness of the dramatic contribution which could be made to a picture by the subtle stress placed upon figures in the foreground. Moreover, this latter emphasis was something that Turner also assimilated from the works of the landscape and history painter, Edward Dayes (1763-1804). *The Archbishop's Palace, Lambeth* (ill. 1) is particularly similar to Dayes' style in this respect. And Dayes may have indirectly influenced Turner's coloring for a short time around 1794 through the influence of his pupil Thomas Girtin (1775-1802), as can be seen in the *Inside of Tintern Abbey, Monmouthshire* (plate #3), in which the bluish cast is especially reminiscent of the coloring found in the works of both Girtin and Dayes. By 1792 Turner also shows marked signs of having come under the influence of P.J. de Loutherbourg (1740-1812), the history and landscape painter. An anecdote relating the two artists is told us by Walter Thornbury, Turner's first biographer, and probably derives from this period:

> It is said that Mrs. Loutherbourg grew very jealous of Turner's frequent visits to her husband, and that at last, suspecting the young painter was obtaining all her husband's secrets from him, she shut the door in his face and roughly refused him admittance.

However, even if Mrs. de Loutherbourg eventually barred Turner from her house, the young painter could still have seen some of the latest productions of her husband on the walls of the Academy, and doubtless did so. And from a memoir written in 1804 by Edward Dayes, we learn that

The way [that Turner] acquired his professional powers was by borrowing, where he could, a drawing or picture to copy from or by making a sketch of any one in the [Royal Academy] Exhibition early in the morning and finishing it at home.

Loutherbourg could well have been someone from whom Turner borrowed works to copy. And although later in life Turner would himself refuse young artists permission to make sketches of his own works when they visited his studio, nonetheless it seems certain that he did as Dayes records, even if few of the copies or sketches made in the Exhibitions have apparently survived. Quite naturally Turner must have borrowed works from Dayes to copy during the early 1790s as well.

It is highly significant that Turner was drawn to both Rooker and de Loutherbourg for they were also undoubtedly among the leading theatrical scene painters of the 1790s. The theatricality of much of Turner's later art may easily have developed from an awareness of the potentialities for dramatic expression which was first stimulated by contact with their productions in both the studio and theater during the last decade of the eighteenth century. Yet Turner also continued to receive stimulus from architectural draftsmen and architects around this time as well. He probably went on working for Malton during the early 1790s and also appears to have first come into contact during the same period with Sir John Soane (1753-1837), whose advice he may have sought about actually becoming an architect. Certainly, Turner was an amateur architect later on in life, designing two houses for himself and perhaps ancillary buildings for others.

In 1791, at the age of sixteen, Turner made the first of his extensive sketching trips out of London in order to obtain material for subsequent pictorial development. He was to make such trips almost annually for the rest of his working life, often staying away from London for weeks

on end and sometimes living in fairly rough conditions while doing so. In the process he amassed over 10,000 pencil sketches in more than 300 sketchbooks which he kept together for later reference. Virtually every watercolor in this exhibition derived from these studies or from memory, since Turner very rarely worked directly from a subject, even in watercolor, preferring the selective process that is enforced by memory to help him arrive more easily at the "poetic truth" of a landscape. (It cannot be stressed sufficiently strongly that much of what Turner represented in his final works—as opposed to studies and sketches—he had *not* necessarily witnessed in the place depicted.) In practical terms, working in the studio also allowed him to be more productive and to exercise greater control over the creative process. In a pattern of touring to be followed similarly throughout his life, in the 1790s alone Turner made the following short or extended tours:

1791 West Country and into Wales
1792 Wales
1793 The Malverns and Oxford
1794 Wales and the Midlands
1795 Wales and the Isle of Wight
1796 Sussex (?)
1797 The North of England, including the Lake District
1798 Wales
1799 Lancashire and North Wales
1800 Fonthill and Kent

In 1793 Turner was awarded the Greater Silver Pallet (sic) of the Society of Arts for landscape drawing. We can judge the quality of the work he was producing around that time from the earliest watercolor in the present exhibition which can certainly be ascribed to his hand, the view of the *Interior of King John's Palace, Eltham*, of about 1793 (plate #1). Probably toward the

end of the following year Turner also began the practice of completing drawings for Dr. Thomas Monro. This gentleman, who was the consultant physician to King George III and the principal doctor at the mental hospital where Turner's mother was later to be committed and subsequently died, had established an unofficial artistic "academy" in his house in Adelphi Terrace overlooking the river Thames. The painter and diarist Joseph Farington tells us that there, on winter evenings, a number of young artists, including Turner, were employed by Monro to trace "...outlines made by his friends &c.—Henderson, Hearne &c. [who] lend him their outlines for this purpose." According to Turner himself, he was paid half a crown or so per evening for his endeavors and given a supper of oysters. There he met up again with Thomas Girtin, whom he had first met a little earlier when they both worked for John Raphael Smith, a printmaker. Farington records that Turner and Girtin were

...employed by Dr. Monro 3 years to draw at his house in the evenings. They went at 6 and staid till Ten. Girtin drew in outlines and Turner washed in the effects. They were chiefly employed in copying the outlines or unfinished drawings of Cozens &c. of which Copies they made finished drawings.

Even by 1794 Turner must have regarded much of this activity as mere hackwork undertaken solely for the money. But, nonetheless, it served a useful purpose for it compelled him to look carefully at—and in the process sometimes assimilate—the stylistic formations of other important artists. These influences included that of Canaletto, for Dr. Monro's next-door neighbor, John Henderson, was an amateur artist and collector who lent his drawings by Canaletto for copying by the "academy"; Thomas Hearne (1744-1817), a topographical artist; J.R. Cozens (1752-1797), the landscape

watercolorist, who was at the time a mental patient under Dr. Monro's care; Edward Dayes; and, of course, Girtin himself, whose influence upon Turner can be detected in works included in the present exhibition such as *Inside of Tintern Abbey, Monmouthshire* (plate #3) of 1794. The watercolor of *The 'Heart of Oak' Inn* (#5) is possibly just such a "Monro School" drawing made in association with Girtin and could easily have been taken from a work by Dayes. In being employed by Dr. Monro to wash in the effects (i.e. provide the light and shade), Turner's role was to superimpose his imaginative responses upon a prosaic outline, which he would continue to do for the rest of his life in his own watercolors. While this employment by Dr. Monro was certainly not the source of such an application of Turner's powers, nonetheless it must have reinforced his propensity to subordinate any regard he may have felt for the literal appearance of a landscape to the truth it held for him in imaginative terms.

Such an inclination to emphasize imaginative responses at the expense of literal concerns could well have been implanted in Turner during the first half of the 1790s by a reading of the Discourses of Sir Joshua Reynolds, whose final lecture Turner almost certainly attended in 1790. Later on in life the landscapist not only avowed his personal indebtedness to Reynolds, but also his sense of aesthetic obligation. Indeed, it is in this latter respect that we can perceive an especially strong relationship between the two artists, for Turner's practice bears out Reynolds' teachings to a quite extraordinary degree. In particular, the allegiance that Turner openly paid to the Academic theory of poetic painting as propounded by Reynolds, a theory which embraces a complex nexus of humanistic and artistic values and which argues that painting and poetry are "sister arts" that enjoy interchangeable powers, seems to have determined the direction that his art took in almost every major respect. It is therefore not at all surprising that when

2 J.M.W. Turner, **Fishermen at Sea,** R.A., 1796; oil on canvas, 91.5 x 122.4 cm.; Tate Gallery, London.

Turner himself came to lecture extensively at the Royal Academy after 1811 he made his allegiance to Reynolds and to the ideals of beauty and the practices of art promulgated by the founding president of the institution very clear indeed.

In 1796 Turner exhibited his first oil painting at the Royal Academy, the *Fishermen at Sea* of 1796 (Tate Gallery, London; ill. 2), a work which especially shows the influence of de Loutherbourg, particularly in the formation of the clouds. However, Turner was not to make his debut at the Academy as a marine artist in watercolor until five years after showing the *Fishermen at Sea*, when in 1801 he exhibited a view of *Pembroke Castle* (which, in any case, is only partially a seascape). Thereafter marine watercolors figure very infrequently among the works Turner displayed publicly (and thus sold to the public); quite evidently he preferred oil paint (and later, engraving) for the widest dissemination of his prowess as

a painter of the sea. One serious consequence of this predilection, however, is that any exhibition devoted to tracing Turner's early development as a watercolorist is fated to ignore his work as a marine painter, for he essayed this subject in "finished" watercolors (i.e. drawings that were intended for exhibition and sale and which are highly detailed and finished, as opposed to sketches) very little in his formative years. There are, of course, a great many watercolor sketches or studies of the sea and marine behavior in the Turner Bequest but unfortunately these works are not available for loan in 1986 since they are being transferred to the new Clore Gallery for the Turner Bequest, due to open in 1987. However, we can certainly judge Turner's early ability as a painter of water and its flowing movement and energy in works included in this show such as *The Angler* of 1794 (#2), *The Cascades, Hampton Court, Herefordshire* of 1795 (#10), and *A river in spate* of 1796 (#13). Obviously, in drawings such as these Turner developed his fundamental knowledge of the interaction of water and solids, even if at this time he articulated his comprehension of their behavior and effects more fully and expressively in his private sketches and studies of the sea, both in watercolor and in oils.

In 1798 a change in the rules governing the Royal Academy exhibitions allowed artists to include quotations from poetry alongside the titles of their works in the exhibition catalogues. Turner immediately embarked upon a public examination of the interdependent roles of painting and poetry, how they could support each other and where the powers of either discipline lay, quite evidently because he believed—as he himself later attested—that painting and poetry are "sister arts". Turner's examination of the respective roles and interactive abilities of the two disciplines is evident in connection with a number of major works produced between 1798 and 1800, including *Warkworth Castle* of 1799 (plate #19). It is worth outlining the progress of this

examination very briefly. In 1798 Turner attached poetic quotations to the titles of five pictures. He did so with some of the works in order to test the ways that painting can realize and/or heighten the imagery of poetry. In others he employed the poetic imagery to extend the associations of the visual imagery itself and thus take painting into regions of imaginative response that it cannot reach unaided. In 1799 he took the process a step further, employing a poetry which is particularly rich in metaphors in connection with the titles of another five pictures similarly to extend works imaginatively into areas that pictorialism cannot go without verbal help. In 1800, with two views of Welsh castles, one of *Dolbadern Castle* in oil (Royal Academy, London) and another of *Caernarvon Castle* in watercolor (Turner Bequest, London), he reversed the procedure by quoting only descriptive poetry which is totally devoid of metaphors, and instead incorporated the metaphors completely *into* the pictures themselves, thus completing the process of assimilation and greatly extending the potential of visual images to convey meaning as a result. Thereafter he did not again quote poetry in connection with the titles of his pictures in exhibition catalogues for another four years. This intensive examination of how painting and poetry might each complement the other would have especially important bearings upon Turner's later development as an artist as, indeed, would his development of visual metaphor, whereby something we see denotes something unseen. And such a process of expressing meanings covertly was also greatly reinforced by the close study Turner evidently made around 1799 of the imagery of Claude le Lorrain (1600-1682). This study he almost certainly undertook not only through examining Claude's paintings but also by looking carefully at two books of prints after his works, the so-called *Liber Veritatis* which consists of a set of 200 mezzotints engraved by Richard Earlom after drawings which Claude had made throughout most of his life of each of his paintings upon

their completion. Claude greatly utilized visual metaphor, and there can be no doubt that Turner recognized such a use. His responsiveness to Claude—who was perhaps the greatest of all painterly influences upon him—had as profound an effect upon his desire to express meaning through his works as it did upon the development of his mature style and imagery.

This is not to say that we have in any way exhausted the influences which can be discerned as having operated upon Turner in the 1790s. Other artists whose work clearly had a strong effect upon him include Richard Wilson (1713?-1782), especially and quite naturally in Welsh subjects; Thomas Gainsborough (1727-1788), and hence Dutch landscape painting by which Gainsborough was himself so strongly influenced; Henry Fuseli (1741-1825), whose direct tutelage Turner probably came under in the Royal Academy Schools and whose influence can particularly be detected in some of Turner's representations of the human figure; J.R. Cozens, whose works the young painter copied in Dr. Monro's "academy" and the breadth and inventiveness of whose compositions and spatial sensibility undoubtedly affected him (as did one particular Cozens oil painting, a picture of Hannibal crossing the Alps); and Richard Westall (1765-1836), one of whose paintings was the only identifiable English picture in Turner's collection other than portrait sketches, and again an artist whose influence can be discerned in the young painter's figures as well as the choice of one or two of his subjects.

Moreover, during these years Turner also gave consideration to fashionable and often highly debated aesthetic questions, including the concepts of the "Picturesque" and the "Sublime". The "Picturesque" is that which was deemed in reality to be "like a painting", either through its associative beauties or its enjoyment of possibly inherent properties such as wildness, irregularity, and roughness of form, and in painting was thought to be like the works of artists who had especially esteemed those properties in nature, particularly Claude, Nicolas Poussin (1594-1665), and Salvatore Rosa (1615-1673). The "Sublime" is that which was held in both nature and art to produce sensations of mystery, grandeur, and even horror, principally through the reduction of the spectator to physical insignificance by means of spatial enormity in reality or amplification through art. While there are signs that Turner considered such ideas and, indeed, expressed the "Picturesque" and "Sublime" qualities of subjects in various works during the 1790s and early 1800s, nonetheless the aesthetic principle to which he himself finally avowed his overriding allegiance was the concept of "Ideal Beauty" as defined by Reynolds and others. The implications of this concept, which stood at the very heart of the notion of poetic painting and led directly to the idealization of subjects and forms, are something we shall analyze in more detail below. But even by the early 1800s the concept of "Ideal Beauty" and all of its ramifications held Turner completely in thrall, if it had not done so earlier, as seems likely.

The rest of Turner's life may be dealt with more summarily for our purposes. In 1799 he was elected an Associate Academician, clearly enjoying enormous promise to reach that status at such an early age. By 1801 he had consolidated the position, taking the Academy by storm with his first great seascape, the so-called "Bridgewater Seapiece", nicknamed after the Duke of Bridgewater who had commissioned the work. By now Turner was going from strength to strength. In the following year, at the age of only twenty-six, he achieved the enviable position of full election as a Royal Academician, a status which guaranteed him a public audience for his art thereafter. In 1802 Turner also took advantage of the brief lull in the war between Britain and France to make his way to Switzerland and experience at firsthand some of the most majestic scenery in Europe. The fruits of this tour made themselves apparent not only on the

walls of the Academy in 1803, but also in a large number of works created over the next fourteen years before again he had a chance to visit the Continent. Watercolors resulting from this tour, but which date from long afterwards, are included in the present exhibition (plates #27 and #28).

During the ten or so years after 1803 Turner greatly expanded his activities. In addition to being constantly busy as a painter and watercolorist, in 1804 he opened his own gallery, while in 1806 he embarked upon an ambitious project to engrave a number of his works (of old as well as new designs) in mezzotint, a project entitled *Liber Studiorum* in homage to the similar series of mezzotints after Claude's *Liber Veritatis*. He also entered the study of artistic theory and practice that ostensibly pertained to the science of perspective, having

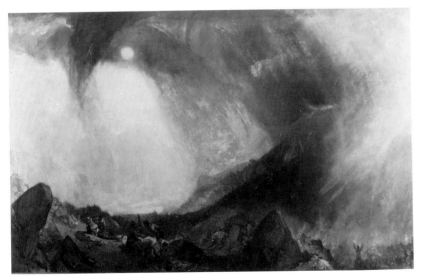

*3 J.M.W. Turner, **Snow Storm: Hannibal and his Army crossing the Alps**, R.A., 1812; oil on canvas, 146 x 237.5 cm.; Turner Bequest, London.*

been elected the Royal Academy Professor of Perspective at the end of 1807. He delivered his first series of perspective lectures at the Academy in 1811 and continued those lectures almost annually until 1828. In 1811 he discovered the pictorial potentialities of line-engraving, and thereafter this medium called forth some of his finest watercolors made for subsequent engraving, being almost immediately responsible for the first major series of landscape line-engravings with which he was associated, the ''Picturesque Views on the Southern Coast of England'' scheme to which four works in the present exhibition belong (#29, #31, plate #39, and plate #40). Also sometime in the ten or so years after 1803 Turner made a special point of renewing his observation of nature—for he was almost exclusively a studio painter—by painting directly from the subject by means of a boat on the Thames and from its banks (see #23 and plate #24 which may have been made in such a way). He also sketched in oils on the Thames in this manner and again painted in the open air a good deal in 1813 during a second tour of the West Country, which he embarked upon in order to obtain further material for the ''Southern Coast'' series. And, as if all this activity were not enough, in 1812 Turner even acted as the supervising architect of his own country villa, Solus or Sandycombe Lodge at Twickenham, to the west of London.

Between 1812 and 1820 Turner went into veritable ''overdrive,'' sending to the Academy pictures of even greater importance than anything he had produced before, works like *Snow Storm: Hannibal and his Army crossing the Alps* of 1812 (Turner Bequest, London; ill. 3), *Frosty Morning* of 1813 (London, *idem.*), and culminating in *Crossing the Brook* of 1815 (London, *idem.*; ill. 4) and *Dido building Carthage* of 1815 (National Gallery, London), the latter picture being regarded by the artist as his *''chef d'oeuvre''*. And a regular succession of masterpieces of similar quality followed.

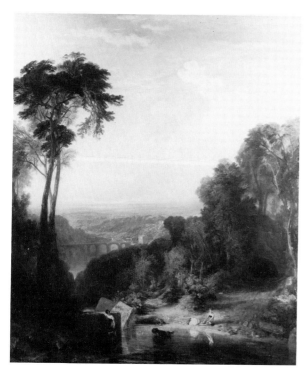

*4 J.M.W. Turner, **Crossing the Brook**, R.A., 1815; oil on canvas, 193 x 165 cm.; Turner Bequest, London.*

In 1817 Turner again revisited the Continent, making a tour of the Low Countries and travelling down the Rhine. Several pictures in this exhibition emanated from that tour (#33, #34, plate #35, and #36). In 1820 he travelled to Italy for the first time, producing over 2,000 sketches in two months and laying the foundations for a preoccupation with Italian subjects that was never again to desert him. During these middle years of his life the artist was also frantically busy producing works for var-

ious engraving series, including a "History of Richmondshire" (plate #30, #37), the "Southern Coast" series (plates #39, #40), a set of illustrations of *Byron's Works* (plate #41), and, supremely, the major project to produce engravings from his watercolors, the "Picturesque Views in England and Wales" series which started in 1825 and for which Turner was to go on producing major watercolors until 1837. The "Picturesque Views in England and Wales" series has been called "the central document in Turner's art", and the six watercolors from it which are included in our exhibition (plate #42, plate #43, #44, plate #48, #49, and plate #51) represent, in just proportion, the importance of the series within Turner's watercolor *oeuvre* as a whole. During the 1825-37 period the painter also created memorable watercolors to illustrate Sir Walter Scott's prose and poetic works (plates #45, #46 and plate #54) and the poetry of John Milton (plate #47).

As well as seeing his fiftieth birthday, 1825 was to prove a watershed of another kind for Turner, however, for with the death in the early autumn of his great friend and patron, Walter Fawkes of Farnley Hall in Yorkshire, the artist was reminded very forcibly of his own mortality, especially because Fawkes was only six years older than he was himself. Fawkes' death was followed by other events "of the same dark kind" in the immediately succeeding years. But perhaps it was the death of Turner's father in 1829 which caused the artist to reach his lowest point emotionally. Ruskin perceived a change in Turner's art around 1825 (without ascribing it to any particular cause), seeing it in a deepening of both Turner's sense of color and his awareness of the beauty and transitory nature of things, and it is difficult not to agree with him. Yet while Turner appears to have responded to the external world with an increasing alertness to its beauty from the mid-1820s onward, often where man is concerned he essayed some of his more pessimistic statements in the final third of his life. One

can certainly see how a heightened sense of mortality cannot but have reinforced his innate moral propensity to think of man as pathetically insignificant when viewed in relationship to the immensity and beauty of external nature. For example, in the superb *A scene in the Val d'Aosta* of around 1836 (plate #53), the tiny figures on the right not only lend scale to the enormous mountains beyond them but may well also have filled just such a moral role for Turner, pointing up the puniness of man by comparison. Turner had always been a great moralist—indeed, moralism forms one of the great cornerstones of his art—but during the 1830s and 1840s the painter's sense that "all is vanity" became ever more acute. Only the natural world beyond man offered him any consolation, and that it did to an increasing degree.

After the death of Fawkes, Turner never returned to Farnley Hall where he had often stayed and painted happily (plate #38). Instead, from about 1826 onward he found a substitute "home away from home" at Petworth House in Sussex, the outstanding country seat of another of his major patrons, the third Earl of Egremont. There he painted, fished (his favorite recreation), and enjoyed the company of a good number of artists who also partook of the earl's benevolent and cultured hospitality. After the death of Egremont in 1837 Turner never returned to Petworth either.

During the 1830s Turner threw himself into his work with increasing dedication, producing not only a succession of masterly oil paintings, but also a multitude of incomparable watercolors. From 1833 onward he created memorable pictures of Venice, a city with which he is especially associated. He also returned to the Alps and may have made a major tour of them in 1836 (plate #53). During this decade he also demonstrated his virtuosity by completing pictures on the walls of the Royal Academy in front of his fellow artists, probably both to upstage them and to remind them forcibly that he was not losing any of his powers as he grew older. Quite naturally he

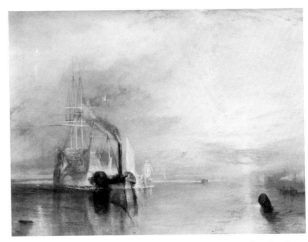

5 *J.M.W. Turner,* **The Fighting 'Temeraire', tugged to her Last Berth to be broken up, 1838,** *R.A., 1839; oil on canvas, 91 x 122 cm.; courtesy of the Trustees, National Gallery, London.*

amazed many of them with his prowess. In 1839 he exhibited a work which certainly stilled any criticisms that his art was either old-fashioned or formally "indistinct". *The Fighting 'Temeraire', tugged to her Last Berth to be broken up, 1838* (National Gallery, London; ill. 5) was immediately recognized as being perhaps the greatest of all British marine paintings, a status it has never lost. In 1840 and the three following years Turner travelled through Germany to Switzerland, producing some of his greatest watercolors as a result. Works thought to emanate from those tours are on display here, including the quite outstanding *Heidelberg: Sunset* of around 1841 (plate #55) as well as the beautiful view of an alpine lake known as *Lake Brienz* of about 1846 (plate #60). During the mid-1840s Turner revived a number of subjects he had developed earlier in the *Liber Studiorum,* and it is to this "late-Liber" series that the Taft

Museum's oil painting of *Europa and the Bull* of around 1845 belongs.* The group of paintings perhaps stands as the summation of Turner's art, expressing a visionary response to the world but one far removed—in the painter's mind at least—from any aesthetic response that is akin to Impressionism, for there can be little doubt that for Turner the power of the sun which floods these pictures with light was not simply a source of hedonistic pleasure, but more a metaphysical (and thus a moral) force, being the expression of a belief that "The Sun is God", a phrase the painter is reputed to have uttered shortly before his death and which upon the available evidence we may well believe he did say.

There are reasons for thinking that from about 1848 until his death in 1851 Turner did little more painting; only in 1850 did he summon forth his last remaining vestiges of strength to exhibit four final oil paintings at the Royal Academy. Characteristically they were all historic subjects, and thus "moral" landscapes, treatments of the "Dido and Aeneas" theme. But by the time of his death in December 1851 Turner's life's work was complete, having brought forth some 550 oil paintings, nearly 2,000 "finished" watercolors, upwards of 19,600 "private" watercolors, rough color studies, or layouts for pictures, and pencil sketches contained in more than 300 sketchbooks—an immense legacy indeed. It is not surprising that 135 years later we are still coming to terms with such a huge body of work. Not until next year will we even see the partial realization of one of the ambitions of the latter part of Turner's life, namely the creation of a gallery solely dedicated to the display of his pictures. But the effort of deciphering his meanings and coming to terms with his output will continue for a long time yet, so complex a painter and thinker was he. England was very fortunate in producing not merely one creative artist of the stature of Shakespeare; the richness of thought, feeling, and language of the Bard was equaled by another, even though it is sometimes open to question as to whether the world still fully realizes that fact.

The medium of watercolor played a central creative role for Turner throughout his long life. Constantly he used it not only to rough out more complex works, both in watercolor and oil, but also he developed its own inherent expressive and representational potentialities to unprecedented and unsurpassed degrees, pushing it to new limits of technical tolerance in the process. Turner would saturate entire sheets of paper with color. He would work wet paint into wet paint, and scratch out highlights with his thumbnail which he kept especially sharpened for the purpose. He would prepare batches of paper with color, which could then be subsequently rubbed out where necessary to reveal the white paper underneath. He would use breadcrumbs to take out small highlights and sponges to take out large ones. Tiny marks were stippled in order to create textural vibrancy and variety. Turner also selected different kinds of manufactured colored papers for separate series of watercolors in order to bestow a particular kind of unified identity upon each series while also setting himself fresh challenges to be solved in working those different supports. The artist would experiment with new colors such as Schweinfurt or emerald green, available in the 1810s, and French ultramarine, available in the following decade. He would also mix gum with his watercolor in order to inhibit the viscosity of the paint. Always he

*NB Traditionally the Taft Museum has titled this picture **The Rape of Europa** and dated it to around 1836. However, it is now accepted that the work dates from around 1845. See Martin Butlin, "Turner's Late Unfinished Oils: Some new evidence for their late date", **Turner Studies**, Vol. 1, No. 2, pp. 43-45; Eric Shanes, "The true subject of a major late painting by J.M.W. Turner identified," **The Burlington Magazine**, May, 1984, Vol. CXXVI, pp. 284-288; and entry 514 in Martin Butlin and Evelyn Joll, **The Paintings of J.M.W. Turner**, 2nd ed., 1984, where the painting is titled as **Europa and the Bull**.*

sought to enlarge the scope of the medium both for expressive and creative reasons.

Such a technical expansion was utterly rooted in a confidence of technique which had slowly evolved through an extraordinarily painstaking training in the medium of watercolor. And upon the basis of that technique Turner's art developed as a whole; from the late 1790s onward the painter not only forced watercolor into being capable of achieving all of the effects that it is possible to encompass with oil paint, but equally pushed oil paint toward achieving the kind of brilliance and luminosity that watercolor more easily attains. This is not to argue that Turner did not differentiate between the two media; he did, but mainly because of their cultural roles, not because there was much he could achieve in one medium that he could not accomplish in the other. Watercolor was fast to work with but more intimate in response and public appeal; oil paint was slower to handle but more highly regarded culturally and more publicly assertive through its capacity for deployment over much larger surfaces. Ultimately, however, both media became capable of realizing Turner's visual aims because underlying each of them there existed the common foundation of a profound certainty of acute tonal control and sensitivity. Undoubtedly this certainty was initially acquired from the practice of watercolor.

Such a foundation was laid in the 1790s. The hours that Turner spent at the very outset of his career in drawing and coloring architectural elevations and views definitely provided him with a sense of the precise tonal values of things, as well as an immense control over both subtle and broad washes—an elementary skill, if not *the* fundamental skill, for anyone wishing to practice as a landscapist in watercolor. This control of tone and of washes can be seen to especially fine effect in two early-period watercolors in the present exhibition, the *View on the Sussex Coast* (#11) and *Brighthelmstone* (#12), both dating from around 1796. In the latter work particularly, the tonal lightening toward the center of the picture is sustained with tremendous control and fluency, the modulation of tone gradually pulling the eye from the right so as to make it follow the incoming motion of the sea.

Yet the control of washes not only concerned what Turner put into his watercolors; as strongly it influenced what he could take out. In this he was valuably aided by the strength of the paper that was available to him. Not for the first or last time in cultural history, what it was possible for an artist to achieve was a direct reflection of the materials that he could explore and exploit. A valuable insight into Turner's employment of what we might term subtractive, as opposed to additive washes, as well as into the nature of the paper he used, the technique he employed to make watercolors *en masse*, and even the degree of intellectual effort he put into his works, is afforded by a passage in John Kay's short book, *Paper, its history*, published in London in 1893, which is reproduced here for the first time since:

Though drawing paper, by which I mean such as is used for watercolour painting, &c. has as much care devoted to its manufacture as human ingenuity can devise, the makers cannot produce now such really good quality paper as was made, say sixty years ago, in consequence of their inability to obtain such good material as the older makers had. The quality of the rags now-a-days is much inferior and even the best linen rags, through being made from poorer stuff, do not give so good a paper as they should. In old times the paper was made principally from "stay cuttings", the triangular pieces cut out of the best and stoutest linen, which was used for making women's stays. If one of my readers is so fortunate as to possess a drawing by J.M.W. Turner, R.A., and will examine the paper, he will find that, though much thinner than that in general use now it is very hard, and with a fine and even grain, and to this a not

inconsiderable part of the beauty of Turner's drawings is due. You never see a brush mark in any of his work, the picture is there, but there is no effort or sign of its construction to mar its illusion, consequently a small drawing of 6 inches square will perhaps convey the impression of half a county almost. The reason is this, Turner, when painting in water colours, generally had several drawings laid down on the same board, which he worked upon one after the other. A great deal of his wonderful charm was produced by constantly washing his work and so getting that extraordinary softness and appearance of distance and atmosphere, and only washing frequently would give him this result. He used to work away on one drawing and then wash it partly out, then turn the board round and go on with the next, and so on, and if he had four drawings on his board, by the time he had worked on and washed his fourth picture, No. 1 would be dry and ready to be worked upon again. But if it had not been for the paper being so tough as to stand all this knocking about, without becoming pulpy or buckling, he would not have been able to have given us the many beautiful pictures he has. Some of this paper is still to be bought, though at the somewhat prohibitive price of a guinea a sheet, but I don't mean by that to infer that anyone purchasing a sheet of it would be able to produce a Turner, for though he washed his drawings so much, somehow he managed only to wash off the superfluous paint, he didn't wash off that with which, he is reported to have said on one occasion, he mixed his paints—viz., his brains.

Kay may well have obtained his observations of Turner's working methods from someone who had witnessed the artist at work, and they certainly receive verification from people who are known to have done so. And undoubtedly Turner's employment of washing and rubbing-out to obtain effects began in the 1790s. In what is probably the earliest drawing in this exhibition, the *Interior of King John's Palace, Eltham* of around 1793 (plate #1), we can very easily discern areas of washed and rubbed paper at the bottom of the drawing. In time the floating and washing-out of colors would become a vital part of Turner's technique, as Kay maintains and as we can easily still appreciate in pictures like *Heidelberg: Sunset* (plate #55) and *Lake Brienz* (plate #60).

In addition to aiding Turner's control of washes, the long training which the young painter underwent in working for architectural draftsmen such as Malton, Hardwick, and Porden also gave him a profound appreciation of the expressive and structural value of pictorial perspective which he would later attempt to pass on to others, both verbally and visually. Malton, in particular, cannot but have enforced such a predilection since in his own works perspective enjoys a marked stress. And also instilled in Turner as a youth, but not necessarily developed much further by these exemplars, was an intense awareness of the nature and variety of surfaces. Here Malton may have seemed especially deficient, for he tends to give broad surfaces the same all-over value rather than any variety; perhaps this is why his influence on Turner palpably waned around 1791-92, to be supplanted by that of a painter who was much more intensely responsive to the varied surface values of things, both materially and tonally. This was Michael Angelo Rooker who perhaps more instrumentally than anyone at this time made a crucial contribution toward Turner's development as a tonalist, and thus as a colorist, for acute control of tone was to be the ultimate secret of Turner's control of color, as we shall see. By enabling Turner to differentiate the most minute tonal variations in things, Rooker was indirectly contributing toward another vital area of the younger painter's art. This all came about because perhaps more than any other contemporary topographical watercolorist Rooker observed

with extraordinary thoroughness the tiniest tonal variation of each brick or other constituent element on the surface of a building. By emulating Rooker in this respect, Turner was setting for himself the indirect goal of attaining the maximum possible tonal variety, and it is a mark of his precociousness that he soon achieved that goal and indeed quickly went far beyond Rooker in tonal inventiveness. Turner's debt to Rooker is something we shall return to, for it had other important ramifications as well. Yet soon after coming briefly under Rooker's spell, Turner's ability to differentiate between the most minute tonalities also received additional reinforcement. Clearly those great many winter evenings that he spent in the company of fellow watercolorists in Dr. Monro's house added to his acute control over light and dark, employed as he was in solely applying the tonal level to pictures by means of washes. It was this tonal control which, once mastered, always enabled Turner to maximize the range and brilliance of his images, as well as their subtlety, and we can easily see that it determined his later development as a colorist, especially in those many pictures or areas of pictures that are governed by a single overall color but within which there are a phenomenal variety of subsidiary variants of the dominant color that are frequently used to signify the forms. Such a variety was principally arrived at through the immense control of tone, and a good late example of the process will be given immediately below. Naturally, such tonal control was also to be of the maximum usefulness to Turner when he came to explore the medium of black and white engraving after his works.

This tonal control was exercised by dint of a characteristic of mind that evidently arose from Turner's first training but which is rarely, if ever, commented upon in connection with the artist's disposition, namely patience. Faced with the extreme expressiveness of his works it is understandable that such a characteristic is overlooked, but it was undeniably constantly present throughout his career. Evidence of Turner's patience abounds in his works from beginning to end, whether in the extreme detailing he provides in the depiction of subsidiary forms such as brickwork, foliage, and rigging or in the provision of contributory marks, such as the aforementioned stipplings which must have taken hours of patient working. You need look no further than *Heidelberg: Sunset* (reproduced in detail on the front cover of this catalogue and as plate #55) to see the proof of that assertion. The dense web of stippled marks in the sky and across the opposite bank of the river Neckar, coupled with the multitude of fine lines denoting buildings, rows of vines, and trees, can only have been painted slowly and laboriously. Indeed, we know from documentary evidence that the artist would sometimes work over a period of weeks upon a single drawing, and it is not difficult to see why (nor why he complained of exhaustion at the very thought of painting trees later on in life). But no less evident than Turner's extreme patience in the *Heidelberg: Sunset* is his acute tonal mastery. The far bank of the river and the town upon it on the right arise out of the iridescent haze of a single color (even if that color does vary slightly in intensity) and were created by an artist who was capable of the most incredible tonal precision, differentiation, and control. Yet, as with other qualities, this iridescent haze or optical dazzle is certainly apparent in Turner's earliest work. For example, in the *Interior of King John's Palace, Eltham* (plate #1), Turner gradually lightens the tone toward the bottom right-hand corner of the work so that the man and horse are almost lost in such a dazzle. Quite evidently the artist wished to communicate the overpowering brilliance of the light entering the dark interior from the left. We can even see how the paper has been rubbed away at the center in order to heighten that effect. At the very start of his career Turner obviously wished to create the widest possible tonal contrasts and to state his awareness that light enjoys the power to eradicate our perception of

matter by its force. As we can see with *Heidelberg: Sunset* of around 1841 (plate #55) and elsewhere, such an eradication would in time become central to Turner.

That awareness of the power of light could only be stated by an eye and a hand that were trained to the highest degree of tonal control, and by a mind that was eternally patient in its quest for denotive and expressive effects. We can again determine to an exact degree how this patience and tonal control were instilled in Turner by his early training if we look at another drawing that is included in the present exhibition, the uncompleted *Tonbridge Castle, Kent* of around 1795 (#6). The picture is a "Monro School" watercolor and, if we remember Farington's diary entry that "Girtin drew in outlines and Turner washed in the effects", then there is a strong likelihood that the tonal levels in this work are by Turner. Yet because the picture is unfinished it demonstrates particularly clearly the levels of underpainting that Turner would have habitually employed in order to build up slowly the tonal density and variety of a watercolor. Clearly, broad areas of middle and dark tone have been dealt with first, leaving a large, underlying lighter area in the center—which acts as the dramatic focal point of the picture—to be filled in more carefully and delicately at the end. The area of maximum dramatic, architectural, and formal interest is thus given the greatest tonal prominence and reserved for the utmost care.

The principal subject to which Turner initially dedicated this tonal control and patience would subsequently also serve him well. Even if the other "Monro School" work in this exhibition, *The 'Heart of Oak' Inn* of around 1794 (#5), is not entirely from Turner's hand either, nonetheless it certainly does demonstrate how renderings of buildings could be projected in ways that are not stiff and lifeless but filled with a sense of subtle dynamism precisely because of a patient concern for tonal variety. Turner may first have derived such a concern for the tonal ranges of architectural surfaces from Rooker around 1791-92, but by 1794 it was already well assimilated. In *The 'Heart of Oak' Inn* the soft gradations of tone within each area of brickwork, as well as across the wooden shuttering and over the glass create a variety of patterns that are never static; rather, the whole surface of the building seems to be gently animated.

Naturally, Turner's early response to the tonal variety of surfaces can best be seen in those works that are completely his own. For example, if we look at *Christ Church, Oxford* of 1794 (plate #4) we can discern to a much greater degree than in those works only partly by Turner's hand a remarkably subtle and varied responsiveness to the play of light across architectural surfaces, with the white paper allowed to shine through on the end walls of the cathedral as well as upon its tower. And an equal amount of care is also given here to differentiating between the forms and densities of the foliage which stands before the cathedral and its tower. Moreover, equally throughout this leafage can be seen a powerful sense of implied movement, a directionality given to the leaves and their clusters which greatly adds to the overall dynamism of the image, partly by contrast with the stability of the buildings beyond. In such a dynamism it is again possible to discern an external painterly influence, for something of the same restlessness is commonly encountered in foliage by Thomas Hearne, whose drawings Turner would certainly have "copied" in Dr. Monro's "academy" between 1794-97, but which evidently he may have known long before beginning his evening classes there, Hearne's influence upon Turner's work having become apparent from about 1791 onward. Here, as with the influence of Rooker, we can once more see Turner responding to the sense of animation brought to things by another artist, only more so: there is nothing quite so seemingly animated as Hearne's foliage in Rooker's work. Time and again in the early Turner we see the artist assimilating the most dynamic qualities of the works of others in order to find a way forward for the

expression of his own most forceful and romantic impulses; once mastered, they could be tamed at will, and indeed were so in the case of the Hearne-influenced "dynamic" foliage, for very quickly Turner abandoned such an easy mannerism. Only later, around the early 1810s, would something far more subtle, transfiguring, and expressive appear in Turner's representations of trees and their foliage. That subsequent quality would be inextricably coupled with a newfound awareness of the value of line and of the way that line can be imbued with an implied sense of motion. By the mid-to-late 1810s Turner's responsiveness to line would indeed become something quite wonderful, as can be observed in works in this exhibition like *The Woodwalk, Farnley Hall* of about 1818 (plate #38) with its elegant lines running up the trunks of the trees or along their shadows and a fallen tree; in *St. Mawes, Cornwall* of about 1822 (plate #39) with its subtle lines running along the mound of pilchard fish at the bottom or the hillsides and castles at the top (and also note the intensely subtle tonal differentiations of the town on the right); in the quite breathtaking *The Death of Lycidas* of around 1834 (plate #47) with its circle at the top and paired subsidiary circles below, and lines of quite phenomenal dynamism running up into the center and at the sides (and here, too, note the stippling, rubbing-out, scratching, and filigree lines); or in *The Whale on Shore* of around 1837 (plate #54) where a series of curving lines pick up and subtly amplify the curvature of the whale at the center (and here, once again, patient stipplings and filigree lines are evident in abundance). Such an awareness of the expressive potential of line seems the natural ancillary of Turner's responsiveness to pictorial dynamics in the 1790s and was, indeed, clearly a refinement of it. The emergence of a subtly serpentine quality in that line could also well have resulted from the influence of William Hogarth, for before 1807 Turner is known to have read Hogarth's *The Analysis of Beauty,* which advocated the "serpentine line

of beauty", although it has not been ascertained exactly when he did so. Yet even if Turner is extremely unlikely to have agreed with Hogarth's proposition that certain kinds of lines enjoy *fixed* qualities of beauty, nonetheless such a viewpoint might certainly have made him more aware of the expressive value of line *per se.*

Another great perception also clearly developed very early on in Turner as a result of his close engagement with both architecture and the works and practices of architectural topographers and fellow painters such as Malton, Rooker, Dayes, Hearne, and Girtin. This was his awareness of the inner structural dynamics of things. Because human architecture is founded upon principles of organic interplay that are certainly paralleled in—if not even being based upon—those encountered in natural forms, such an awareness served Turner immensely in developing his perception of the underlying stresses and interrelationships of all physical forms, both organic and inorganic, animate and inanimate. In his maturity Turner exhibited a profound comprehension of the underlying tensions and formations of natural architecture, and we can easily perceive the human foundations of that knowledge. For example, if we look at the stratification of the limestone in the middle-period watercolor of *Hardraw Fall* of about 1816 (plate #30), we can see without difficulty that Turner has totally grasped how underlying geological forces have produced the layers, fractures, and fissures in the rock and how subtly he imparts that awareness. But it is not difficult to see from where that consciousness arose. If we look at a watercolor of the 1790s, *Inside of Tintern Abbey, Monmouthshire* of 1794 (plate #3), it is already apparent that Turner has not simply depicted the architecture in "picturesque" terms; he is thoroughly alert to the interactive stresses of the vaulting, the spatial and planar relationships of the walls, the dynamic rhythms of the arches, and the sense of mass and volume everywhere. Naturally, through exercising an impressive control over tonal relationships he adds

greatly to the sense of spatial recession while also imparting his awareness of the immense variety of surface interplays within the building. The result of all these observations is to heighten our consciousness of the underlying architectural dynamics throughout. In time this comprehension of architectural relationships and interactions would become much more subtly expressed even than it is here and would easily be transferred to natural architecture. By effecting such a transfer Turner undoubtedly felt that he was merely going back to basic truths, for we know from perspective lecture manuscripts which he wrote around 1818 that for him architecture was founded upon a geometry "of whose elementary principles all nature partakes". That geometry consisted of basic forms such as the "triangle or circle, cube or cone" which are universally apparent in cellular and other organic structures and which he firmly believed ultimately enjoy a divine and immutable existence underlying everything. The artist also evolved a similar metaphysical outlook towards light—"The Sun is God" is a thoroughly metaphysical statement—and it is possible to perceive a profound concern with metaphysical essentials throughout Turner's art, for according to his own writings the painter accepted fully the academic notion, best expounded in his own day by Reynolds, that all forms are variants upon an ideal "central form" which it is the supreme duty of the artist to conceive and pictorialize. To this end he had first to study individual objects and phenomenal effects—the appearances and effects of "particular nature"—and, by analyzing their common properties and behavior, arrive at some conception of a fundamental "truth" pertaining to the whole species of form or phenomena to which they belong. This was why Turner felt it vital, as he put it in 1809, to perceive the underlying "qualities and causes, effects and incidents" of things, and why even before he wrote the foregoing (and at the very outset of his career) we can see him puzzling out those very attributes within individual natural objects: from the start Turner proceeded as he intended to continue. Thus it is possible to take two entirely reconcilable views about a drawing such as *A great tree* of around 1796 (plate #14). On the one hand it is undeniably a study of an individual object, whose very individuality and sense of character supplies the initial point of departure for the artist. But if we look more carefully we can also see that although Turner is still following contemporary conventions of stylization in the way he renders the foliage, nonetheless he is concerned to an unusual degree with understanding and making clear the inherent structure of the beech tree, and thus its generality, delineating with great care its underlying form, organic dependency, and the precise relationships between wood and leaf. This he conveys both by means of tone and through his linear sense, as well as by paying due regard to the precise outlines of each part of the tree. The result is certainly to make apparent some positive sense of energy *within* the organism itself. Eventually Turner's awareness of the inner life of things, or of their underlying dynamics, would be made much more immediately manifest in imagery of great beauty and power. For example, if we look at the trees in *The Woodwalk, Farnley Hall* of about 1818 (plate #38), we can perceive that each trunk and bough, branch and cluster of leaves seem possessed of a sense of life and radiant blossoming. What was still being tentatively explored in *A great tree* has here come to fruition and been completely comprehended.

This maturation of understanding is no less true of the movement of water, clouds, and lightning in later pictures such as *The Death of Lycidas* of around 1834 (plate #47) where we can recognize that the furious surge of the elements seems both possessed of a cataclysmic sense of torment *and* demonstrates a total grasp of the way that energy activates water, clouds, and the vast electrical discharges which can link them. Yet the foundations of this comprehension were, once again,

clearly laid in the 1790s and can be seen especially easily in pictures in the present show such as *The Cascades, Hampton Court, Herefordshire* of 1795 (#10), *Brighthelmstone* of around 1796 (#12), and *A river in spate* of 1796 (#13). In each of these works Turner is not simply concerned with appearances. For example, in *A river in spate* the water really displays a sense of inner propulsion. (This sense of movement is effected by quite limited tonal means and provides evidence, yet again, of the power of immensely subtle tonal differentiation that the young Turner was developing.) Similarly, in *The Cascades, Hampton Court, Herefordshire* (#10), there is a really driving sense of force rushing through the disturbed and furiously eddying water at the top left, which then surges down toward the right. In this work we can also observe that the leafage of the trees, while stated with overall formal coherence and some sense of growth, does not diminish the impact of the surging water by being rhythmically enhanced in the manner of Hearne. Moreover, here too we can simultaneously witness Turner's immense tonal awareness and his resort to one of his favorite pictorial devices, the centering of the area of lightest tone at the point of greatest physical interest: he is, quite simply, attempting to direct our visual experience of the picture. This selfsame direction of attention, but in the depiction of the sea, has already been noted in connection with *Brighthelmstone* (#12) where it is also worth observing that even by 1796 Turner's understanding of the rhythmic flow of water seems complete, although naturally it would later receive more complex elaboration. By the time he came to create *Folkestone, Kent* (plate #40) in the early 1820s, we can see just how profound this understanding had become, with the distant eddies of a calm sea and the underlying countercurrent suggested with arresting subtlety.

Moreover, there is another aspect of the appearance of water which Turner had evidently grasped in the 1790s. If we look at *Newark-upon-Trent Castle* of around 1796 (plate #15), we can perceive an already masterful awareness of the reflectivity of water. This reflection does not in any way compromise the sense of slow movement in that water: both are accommodated with assurance. Similarly, there is also a sense of behavioral formation in the clouds in the picture, and any mannerism in their depiction is already beginning to wane. The artist seems to have looked intensely at such phenomena and what moves them, something that is also apparent in *Brighthelmstone* (#12). By the time he came to create pictures like *Holy Island, Northumberland* of around 1828 (plate #43), with its driving rain, receding storm, and tidal surges, or *The Death of Lycidas* of about 1834 (plate #47), if not long before, the awareness of the underlying dynamics of marine and meteorological behavior was complete. Upon the basis of that total knowledge Turner developed some of his most dynamically expressive artistic statements.

In connection with the latter picture we can also perceive how the inherent limitations of an art based primarily upon the staining with color of relatively small sheets of paper *forced* Turner to differentiate between size and scale: in *The Death of Lycidas* he ushers forth immensities of cosmic space, and all within an actual painted area barely eight inches high by five inches wide. Here, once again, is evidence of Turner's ends deriving from his beginnings. The ability to imbue smallish spaces with a sense of grandeur was definitely learned in the 1790s, as is typically made clear in the *Inside of Tintern Abbey, Monmouthshire* of 1794 (plate #3), where the building towers up over us, an effect that is made more pronounced by the way that the shrubbery and masonry with which Turner litters the middleground are consistently carried up only just above the horizon line of the eye, thus enhancing by contrast the sense of vacant space above them.

Turner's control of space, and his ability to summon forth a sense of huge scale, had its origins in the 1790s

when the artist was predominantly working in water-color. He advanced only cautiously toward depicting objects over very large physical areas, perhaps sharing intuitively the comprehension, best stated later by Robert Schumann, that "great spaces require great minds to fill them", or at least great subjects with which to do so. Turner's largest pictures were not created until the years immediately after 1819. But long before then he had developed the ability to project immense fictive spaces even within relatively small areas. The desire to do so clearly stemmed from a number of factors. Primary among them was the artist's innate need for space: quite simply he required the emotional and psychological release afforded by immensity. This is understandable, given that he was city-born and a city dweller for most of his adult life. For him, no less than possibly for us, escape into the vastness of nature answered something profound. That this was the case appears proven by the fact that Turner's identifications with the enormity of external nature seem so authentic and give utterance to many of his most urgent and intensely expressive out-pourings.

Given such an innate tendency it is easy to understand how Turner's cultural surround could then have acted upon his sense of scale. For example, for a time around 1800 at least, Turner's awareness of spatial dimensions was probably further enhanced by some consideration of the concept of the "Sublime." This held that both a real landscape and its representation could emotionally overwhelm and even frighten the spectator by dint of its immensity, sense of darkness, and mystery. Around the turn of the century Turner's work often became darker in tone and upright in format, with a proclivity for subjects of immense dimensions coming to the fore. However, by about 1803, at least, the darkness had begun to disappear, and the artist then reverted to a preference for horizontal formats, evidence perhaps of his desire to avoid such obvious ways of projecting mys-tery and scale. And another theoretical consideration might have replaced the concept of sublimity—which, after all, is merely a materialistic exploration of things—in determining or shaping Turner's awareness of space and scale. His proclivity to enhance scale could easily have been augmented by his thorough identification with the theory of poetic painting. This theory held that, like a poet, to be taken at all seriously a painter needed to create an art of epic proportions, as had those paragons such as Michelangelo and Raphael whom Reynolds held up for emulation. For Turner, to whom the organization and direction of pictures were often fundamentally determined by the consideration of "poetic" needs, such a requirement would have presented no problems, even if it necessitated the reconciliation of that demand with both the more humble requirements of the market place and with the capabilities of watercolor. One means of bringing about such a reconciliation was to impart to potentially saleable pictures a sense of the necessary spatial grandeur that was required. Here Turner's innate dramatic awareness proved an invaluable help. Even by the mid-1790s he had fully attained the "poetic" ability to imbue the most picturesque subjects with a sublime sense of grandeur, as we can see with the *Inside of Tintern Abbey, Monmouthshire* (plate #3). The same tendency toward spatial enhancement can equally be witnessed in depictions of quite humble rustic subjects such as the *Pembury Mill, near Tunbridge Wells, Kent* of around 1795 (#9), where it may be seen to result from the way that Turner highlights the building, thus maximizing its spatial contrast with its surroundings. (The lines that Turner rubs out across the hills beyond the mill also add to that enhancement of space.) Naturally, in subjects which inherently enjoyed their own sense of magnificence, such a projected grandeur is even more apposite, as we can discern in works of the late 1790s such as *Kirkstall Abbey, Yorkshire* of 1798 (#17), and *Warkworth Castle, Northumberland* of 1799 (plate #19).

By the early 1800s the sense of spatial power in Turner's work can be overwhelming, as in the superb *South view from the cloisters, Salisbury Cathedral* of about 1802 (plate #21), and it is something which never disappears thereafter. Certainly, in the latter picture the choice of a vertical format importantly contributes to that sense of spatiality; but even in less formalized works which employ a horizontal format, such as the earlier *Ullswater, with Patterdale Old Hall* of 1797 (#16), it is also immediately apparent. For Turner spatial enlargement was quite evidently a *sine qua non* of painting, and it is not hard to see why: it formed a central part of his panoply of poetic responses to the world, stating things not as they are but as they ought to be. Because the reality of the poetic imagination transcends the actual, so the fictive spaces enacted by Turner's imagination were constantly augmented in scale.

There was also another central tenet of the theory of poetic painting which quite evidently influenced Turner almost from the beginning. This influence was the fact that an epic poetic art—which is what Turner aimed to create from about 1800 onward—was by definition a profoundly humanistic affair. Yet it was not only profoundly humanistic; it was, as a consequence, no less moralistic since epic poetry and morality were inextricably linked, especially for Turner who in 1811 wrote that the poet and the prophet, i.e. the moral seer, should be one and the same. For him painting was therefore equally a visual, a poetic, and a moral affair. And certainly poetic morality shaped the content of his art, and thus the direction it took.

In Turner's youth, at least, his favorite poets appear to have been Milton and the Augustans, that group of poets who lived in the Caroline or Georgian periods of apparent peace and prosperity, and who included John Dryden, Alexander Pope and Mark Akenside. All of these poets strongly addressed moral issues in their works. But perhaps Turner's very favorite poet was one who, in addition to morality, also particularly concerned himself with landscape as well: James Thomson (1700-1748). In Thomson's poetry we can easily find the closest parallels with Turner's own moral position; it is therefore probably valid to assume that Thomson helped form that position in the first place. In poems like "The Seasons" (1726-30) and "Liberty" (1734-36), Thomson propounded notions of social cohesion and the imperfection of man which find almost exact reiteration in the subjects and titles of pictures and/or poetic quotations appended to those titles that Turner later employed. Above all, however, the Thomsonian view, which was repeated by other Augustan poets known to Turner like David Mallet (1705?-1765), that nature would outlast the vain strivings of mankind, finds expression throughout Turner's art. This view may have been a fairly commonplace sentiment by his day but nonetheless he took it completely seriously. And later on in life he was drawn to poets such as Byron and Shelley who more romantically but no less forcefully amplified that type of sentiment.

An important power of poetry is its ability to project aspects of nonvisual experience. Indeed, we can witness Turner employing a quotation from Thomson's "Seasons" in connection with the *Warkworth Castle, Northumberland—thunder storm approaching at sun-set* of 1799 (plate #19) to attain just that end. Moreover, because morality is an inner determinant of our external behavior, artistic moralism necessitated the projection of our inner life. It was especially in this respect that Turner found the mechanisms of visual association and metaphor particularly useful and a contributory reason why he especially made a point of investigating their expressive potentialities between 1798-1800. Yet such associative devices can certainly be witnessed as operative—albeit in a more simple way—well before 1798. And in order to fully understand their usefulness to him we have to examine what Turner was attempting to communicate, as

6 *Michael Angelo Rooker,* **Interior of the Abbot's Kitchen, Glastonbury,** *date unknown; watercolor on paper, 35.5 x 45 cm.; Tate Gallery, London.*

Glastonbury (Tate Gallery, London; ill. 6), Rooker lovingly represents an old monastic building in terms of its architectural detailing. He pays great care to the tonality of each block of masonry, as well as to the textures of a sculpture, logs of wood, piles of straw, and pieces of washing hung up to dry. But at the same time nothing could be less elevated than the cattle who are housed within the building, and they serve as a reminder of the indifferent level of usage to which the old kitchen had fallen by that day. Turner gives us exactly this same kind of moral staffage in a watercolor of the *Trancept of Ewenny Priory, Glamorganshire* of 1797 (National Museum of Wales, Cardiff; ill.7), exhibited at the Royal Academy in 1797, in which pigs emanate from the nave and the transept is littered with a farrow, a wheelbarrow, a henhouse, and other farmyard objects, as well as a great number of chickens. Such low usages of once holy buildings were commonplace in topographical painting

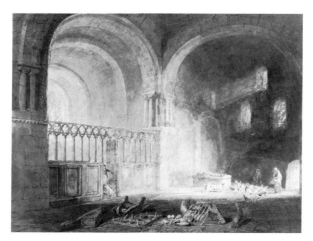

7 *J.M.W. Turner,* **Trancept of Ewenny Priory, Glamorganshire,** *R.A., 1797; pencil and watercolor on paper, 40 x 55.9 cm.; National Gallery of Wales, Cardiff.*

well as how he was saying it. One area of content can prove particularly helpful in this respect.

Throughout Turner's life ruins or near-ruins were a favorite subject for the artist. But this was not simply because he found such objects merely picturesque, and even less was it because they provided extremely attractive subjects to potential buyers of his works, even if that may initially have been the case at the outset of his career. Clearly, buildings in a ruinous state maintained their attractiveness to him and indeed increased in that attraction quite simply because of their moral associations. Such links were commonplace in art during Turner's formative years, and it is easy to perceive how works projecting those moral connections could have influenced him. For example, in a watercolor by Michael Angelo Rooker of the *Interior of the Abbot's Kitchen,*

during the eighteenth century, being a frequent sight in reality, but they did allow artists to make moral statements, for of course it would have been easy to fill such scenes with more elevated staffage or even leave them empty. Instead, by representing the contemporary degradation of historic buildings an artist could not only intensify the picturesque qualities of a view; the moral value of the scene would also be enhanced in order to remind the viewer of the transience of human affairs. Certainly, Turner's drawing owes nothing anymore to Rooker in pictorial terms, being influenced perhaps by Piranesi or Rembrandt. Yet the debt in dramatic terms, if not a direct one from picture to picture, nonetheless seems a fairly possible one from painter to painter, given Turner's susceptibility to Rooker's work around 1791-92. Rooker was but one of a number of important early influences upon Turner who forced the young painter to consider both the level and role of his staffage and its judicious usage in a composition. He also perhaps indicated to Turner the associative value that staffage can contribute to a picture.

We can actually see evidence of the growth of this thinking in works on view here. For instance, in the *Inside of Tintern Abbey, Monmouthshire* of 1794 (plate #3) Turner does not employ his figures or any other means to draw attention to the moral associations of the ruin. He simply responds to the ''Picturesque'', i.e. irregular and characterful qualities of the scene, such as the Gothic architecture itself and the way it is covered with ivy, moss, and lichens. However, in the *Newark-upon-Trent Castle* (plate #15) of about two years later decidedly he does underline the moral implications of a ruin. This moralism is enforced by means of the association of images and ideas, to link the ruin with modern times and thus state a moral. On the river bank immediately in front of the decayed castle Turner places a wrecked boat. The broken timbers of the boat exactly echo the similarly broken beams of a castle window high above them. Naturally, Turner expects us to make a con-

nection between these ruined objects of present and past quite simply because of the purposeful vertical alignment and visual similarity of their components. He adds further to the forlorn mood generated by the castle by leaving the river in front of the main part of the building completely empty and by placing a solitary boat on the shore to the right. Yet even if it may be too early in Turner's career to see in this treatment of ruins the kind of moralistic and pessimistic statement concerning the ultimate ruin of man's aspirations and grandiose conceptions—as represented by the castle—which we frequently encounter later in his art, nevertheless a moralistic connection between ancient and modern ''ruins'', whether they be of the literal or of the poetic kind, is undeniably present. And we can certainly see a similar moral addressal in another early picture in this exhibition. In the *View of Tonbridge Castle, Kent* (#6), the conjunction is enforced between the ancient pile and the more modern but rickety jumble of buildings immediately in front of it. This linkage is brought about not only by means of the vertical alignment of the buildings but also by the tonal highlighting which has already been remarked upon. There can surely be little doubt that if Turner had finished the drawing, such a tonal relationship would have been maintained in some way. The connection between the stolidity of the old building and more recent architectural feebleness tends toward wit rather than seriousness, but it is a moral conjunction nonetheless.

In time this associative power would develop enormously in Turner and become a vital imaginative feature of his art. Indeed, the painter welcomed the strain that the association of images and ideas puts upon the imaginative faculties of his audience, for it forces us to look carefully at his pictures if we are at all to make sense of them. And another watercolor included in this exhibition fully indicates the immense communicative power that the artist would subsequently command by means of the

kind of association of images and ideas which was first explored in the *Newark-upon-Trent Castle* (plate #15) and *Tonbridge Castle* (#6) drawings. This work is the *Powis Castle, Montgomery,* dating from around 1834 (plate #48).

In the distance is the medieval castle standing above terraces that descend to the river Severn. On the right a hunter positions himself to shoot a heron which stands on the left in a compositionally balancing position. Turner appears to elaborate both the sense of preoccupation in the hunter and the richness of life in the bird by an associative employment of the trees which he ranges immediately above them: the straightness of the hunter's aim is perhaps advanced metaphorically by the straight trunks of the maple trees above him, while the sense of life in the bird seems to be amplified by the manifest flowering of the elder trees placed above it. These connections are also furthered by associations of color and tone: the dark green of the maples reiterates the color of the hunter's jacket and the light tones of the elders echo the light tones of the bird in front of them. Moreover, the curve of the heron's neck is also amplified by an identical curve which exists between the two main tree trunks on the left.

We should not be unduly surprised that in *Powis Castle* (plate #48) Turner employs landscape as a peg upon which to hang a moralizing statement about avian life and death; here, too, once again, is evidence of his deep assimilation of the humanistic principle of the theory of poetic painting, for of course what we are witnessing is yet another of Turner's moral contrasts, between the beauty of external nature and the folly of man, not just a statement about the impending death of a bird. Nor should we be surprised that Turner might have used trees or other objects or phenomena to advance the underlying or inner meanings of his pictures by covert methods: here the artist definitely left us concrete evidence that he did so, and not surprisingly; such procedures were ''poetic''

and therefore pictorially permissable, if not even welcome. They had also been frequently utilized by earlier landscapists such as Claude—from whom Turner principally derived their use from 1799 onward—which was an added incentive to employ them.

Powis Castle (plate #48) is undoubtedly a ''moral landscape'' in which the moral is an *addition* to the topographical subject. But obviously it was much easier (because more direct) to state a moral *through* the subject itself. This is why ruins in particular would prove so important to Turner throughout his life. Naturally, there are two ways of regarding Turnerian ruins: where they are seen beyond busy or cheery foregrounds, as in *Holy Island, Northumberland* of about 1828 (plate #43), *Jedburgh Abbey* of around 1832 (plate #45), or *Johnnie Armstrong's Tower* of around 1832 (plate #46), we might regard the foreground activity as being intended to offset any pessimistic associations of the ruins beyond them. Conversely, however, we might see such ruins as continuing reminders of the limitations of the human activity taking place before them and of the ultimate destiny of mankind. But given the overall pattern of Turner's thinking about the place of man in the universal scheme of things, and the way that increasingly he reserved for the treatment of ruins some of his most haunting and elegiac coloring, it does seem likely that the artist usually intended that we should regard the ruins in his pictures through the latter rather than the former perspective. Certainly the pattern we can discern in connection with his later exhibited oil paintings of ruins, which often further specify their meanings through associated poetic quotations, unequivocally draws attention to the fact that in such physical dissolutions of human effort Turner was stating that ''all is vanity''. And that message is also indubitably present in another watercolor of a ruin in the present exhibition, *Dunstanborough Castle, Northumberland* of around 1828 (plate #42), in which the artist places a wrecked boat in the foreground and a ruin in the

background, and thus underscores the "ruin" of both. Again it is not difficult to see a strong link between a moral statement of the later period of Turner's life and one created in the 1790s, as in *Newark-upon-Trent Castle* (plate #15), even if it is not necessarily a direct one between each particular work.

The value of enforcing associations *per se* first became apparent to Turner in the 1790s and could easily have been encountered in comparatively rudimentary forms in many of the landscape depictions of his day where a scene was extended in meaning by a complementary use of figures, animals, or objects in order to point up the associations of place. A gentleman, for instance, might have his country residence represented with associative images of the local agriculture, industry, or commerce from which he derived his wealth placed alongside it. In time Turner would elevate this basic associative procedure to very complex imaginative levels, especially in those great many watercolors made for subsequent engraving either in series or to illustrate books, where he felt it would be especially apposite that the image should not only complement but even augment the meaning of an accompanying text. Nor can there be any doubt that he found it extremely easy to reconcile such demands with his academic idealism. After all, by doing so he was only presenting the essence of a subject, the underlying social, economic, historical, or even moral truth of a place. There are several works in the present exhibition where, in addition to representing the visual beauties of a scene, the artist took special pains to point out this essential human truth of place. These drawings include the lovely *Weymouth* of around 1811 (#29), *Tor Bay from Brixham* of about 1816 (#31), *St. Mawes, Cornwall* of about 1822 (plate #39), and *Oxford from North Hinksey* of around 1835 (plate #50). Characteristically all of these works were made for engraving and thus designed to reach the widest possible audience.

A fine example of this ideality of place is the Taft Museum's own watercolor of *Folkestone, Kent* of 1822 (plate #40), made for reproduction in the "Southern Coast" series of engravings to which Turner contributed 40 images in all. Here the artist depicts local smugglers burying their goods on shore. Folkestone, at the time that Turner first visited the town and indeed for long afterwards, was both dependent upon and famed for its smuggling, and the painter therefore represents the place beyond the human activity which formed the economic basis of its existence. Moreover, he continued to address this subject in other watercolors in which he explores the various stages of a smuggling operation both before and after that depicted in *Folkestone*. The final watercolor in the sequence, not included in this exhibition, shows smuggled goods being seized by Excise officers and thus realizes the adage that "Crime Does Not Pay", evidence, once more, of Turner's desire to use landscape as the setting for moral statements concerning mankind.

One curious and immediately discernible attribute of the Taft Museum's *Folkestone* watercolor (plate #40) is a somewhat simplistic quality in the figures; facially they even seem infantile, inasmuch as the artist reduces their features to a basic formula of dots and dashes to represent eyes, noses, and mouths. However, in communicative terms the faces, as well as the frames to which they belong, are undeniably effective, for they successfully impart the social status of smugglers, as well as the activity in which they are engaged and even, in the case of one of them, how tired he seems to feel while doing so. These people are also superbly integrated into their surroundings, both spatially and pictorially. Yet once again the qualities of a later work can readily be detected in an earlier one, for equivalent attributes of seemingly infantile physiognomy and excellent pictorial integration may be seen in *Pembury Mill, near Tunbridge Wells, Kent* of around 1795 (#9): here are the same kind of dot-and-dash representations of facial features in the miller and the girl on the right, as well as the crucial role that humanity plays

in a landscape. The homely associations engendered by these folk are entirely in keeping with the picturesque qualities of the mill and its setting, and indeed advance them greatly.

Turner's development of his figures, and the importance he gives them within his land and seascapes, was of course something central to the fundamental strain of humanism that runs through his art. But his consistent representation of the human face and frame as something which looks infantile or even, as some critics have argued, doltish and mis-shapen, was not the result of any painterly deficiency on his part. Instead, it was positively contrived from an amalgam of influences: Hogarth, de Loutherbourg (who, under the influence of Hogarth, invented a new kind of genre, the comic landscape painting), Fuseli, Rooker and, above all, the Flemish artist David Teniers the Younger who was famed for his portrayals of a doltish and "low" mankind.

Such a projection of a distinctly unheroic-looking staffage in Turner's art served two main objectives: it made his landscapes seem immeasurably more beautiful or powerful by contrast with the pronouncedly ugly people who inhabit them; and, at the same time, it allowed him to state his moral view of man's place in the universe. Certainly, by representing man in this almost caricatural or "low" way the artist was apparently rejecting a crucial component of the theory of poetic painting, namely that an artist should idealize the human form. But here he was clearly sacrificing what he perceived to be an outer truth for what he deemed to be a more important essential. Man, in Turner's works, is rarely given the opportunity to be heroic, and thus physically attractive. More often than not Turner gives us humanity in a fairly low state because that is how life was mainly lived at the time and how he witnessed it in actuality. In his day the general mass of mankind was uneducated and unwashed, and suffered an extremely precarious existence, as the artist frequently witnessed at firsthand on his travels through many of the more socially deprived areas of western Europe. What better, more truthful, and directly communicative way could there be to express a sense of the general brutalization of mankind at the time than through evolving a suitably "deformed" and doltish figuration with which to match it? Here Turner was certainly stating the essence of things every bit as much as he did in his representations of external nature. Such a realization was natural to a painter who, from the very start, explored the social reality of human existence no less than our physical reality in his works. To match our outer guise to the physical hardship and underlying spiritual, emotional, and intellectual hurt suffered by the major part of mankind in his day must have seemed an artistic imperative that was entirely reconcilable with his academic idealism. And there is no contradiction here: it is possible both to pity the lot of humanity and to feel moralistic about our behavior and destiny. Indeed, the one necessitates the other, or at least did so for Turner.

The artist therefore essayed his idealism as much through his figures as he did through his other forms. In every area of experience he sought out fundamentals, be they essentials of form, behavior, history, or social reality. Usually in the process he gave precedence to the projection of his humanism since it is the existence of man in the world that provided his measure for all things. And the desire to arrive at essentials quickly came to dominate his art. But the diffusiveness of form and the richness of color in his later work should not sidetrack us into believing that he had by then in any way sacrificed his idealism or his humanism on some materialistic altar of pleasure. Turner's late works represent the very apotheosis of his humanist idealism. Instead of representing the here and now he projects an ideal world, one that is huge, immeasurably beautiful, often radiant in its perfection and a visionary dimension which somehow seems more real than anything we could possibly experience in actuality. In several of the late watercolors in this exhibi-

tion, from the *Lake Nemi* of around 1835 (plate #52) or *Heidelberg: Sunset* of about 1841 (plate #55) to the two views of *Sion, near the Simplon Pass* (plates #58, #59) and, supremely, *Lake Brienz* of around 1846 (plate #60), we cannot fail to recognize this transcendant idealism—an idealism, moreover, in which the fundamentals that underlie appearances are necessarily grasped and stated to the full. For even amidst the late diffusiveness there is always a pronounced certainty of underlying form. If we merely glance at *Sion, near the Simplon Pass* (plate #59) in its more elaborate version, we can quickly see that despite the fact that everywhere in the drawing there is a constancy of apparent motion, and that the precise delineation of appearances is often minimal, nonetheless the form is entirely given: sheep, buildings, hillsides, the mountains, all of them exist fully, even if we cannot perceive their every aspect. Representation has surely never been so simultaneously incomplete and total as it is here and in other similar late works by Turner. But whereas oil paint allowed the artist to attain an unprecedented and unsurpassed fictive light in his late pictures, it is only in some of his late watercolors that we can also sense something else of equal value. This has to do with Turner's penchant for tonal modulation toward the end of his life.

We have already commented upon the tonal modulation across surfaces in early works possibly from his hand, such as *The 'Heart of Oak' Inn* of around 1792-94 (#5), or watercolors entirely by him such as *Christ Church, Oxford* of 1794 (plate #4). Such modulation makes its reappearance across the whole visual image in a number of what might well be among the last of Turner's watercolors, works such as *Sion, near the Simplon Pass* (plate #59) and *Lake Brienz* (plate #60). Yet it is difficult to feel that the artist was here enforcing such a constancy of implied motion simply as a stylistic trick or for merely painterly reasons. Turner was always too serious in his aesthetic aims and too complete an artist for that. Instead, such a modulation must have been intended to denote something. And it is not difficult to puzzle out what this denotation might be, once we remember both Turner's idealistic concern for essentials and his related attraction to metaphysics. Increasingly what in many of the late watercolors appears for Turner to underlie the material world is the sense of living energy. Form dissolves, light burns more incandescently and movement seizes everything, acting behind the visible appearances of matter to project a dynamic continuum. But energy is surely not exalted for its own sake here. On the contrary, it could be something which Turner apprehended as divine since the prime source of that energy, as manifested through the medium of light, was the sun which the artist thought of as the deity. Here, clearly, was the ultimate essential to a painter for whom the tracing of essentials through art lay at the very root of his activities. Energy and light appear to have become divine manifestations for Turner, and by the time he created the vibrant *Sion, near the Simplon Pass* (plate #59) and *Lake Brienz* (plate #60) the whole visible universe seems to be filled with them, flowing through contours, unifying forms, and actuating the fictive reality which presents itself to us. But it must be doubted whether this probable sensibility of divine cosmic energy could have been as fully and as triumphantly projected if it had not been for those long, patient hours of washing-in drawings during the 1790s. The constant and intensely subtle modulation of tones, which in the beginning merely served to denote the fall of light across variegated surfaces or the differences of local color in brick and stonework, finally enabled Turner to project the universal and constantly modulating harmony which he conceived of as underlying everything. This modulation was the most extended legacy of his patient initiation into the art of watercolor painting in the 1790s, and it was a legacy which he owed primarily to that training.

It is understandable that Turner is still principally

regarded as a landscape and marine artist. The modern taste for French Impressionist landscape painting and our understandable reaction against nineteenth century moralism and literary values in art have undoubtedly made it difficult for us to perceive Turner in any other way. But he was much, much more than simply a landscapist. Throughout his life Turner sought out meaning in the world, attempting in his art to find answers to ultimate matters. It is a mark of his commitment to serving that end that even in the comparative handful of watercolors in this exhibition, including several very early ones, we can nonetheless detect strong evidence of such an impulse. It is only by recognizing that Turner's art projects something much greater than merely intense, pleasurable responses to the external natural world, or that overall it is far more than simply a "journey" from seeming darkness to light, and instead perceive how it embodies a vast nexus of physical, poetic, humanistic, and metaphysical concerns, that we can perhaps take better stock of what he has to tell us.

NOTES ON THE CATALOGUE OF THE EXHIBITION:

Where possible the works in this exhibition bear the titles given by the artist and his idiosyncratic spellings of place names are retained. The term drawing used throughout this catalogue is the traditional appellation for watercolors.

The watercolors, drawings, and sketchbooks of the Turner Bequest are at present withdrawn from public access but they will be available in the Clore Gallery for the Turner Bequest which is scheduled to open in 1987. The oil paintings in the Turner Bequest are on display in the National Gallery, London, and the Tate Gallery, London. The latter group of works will be transferred to the Clore Gallery in due course. The inventory of the bequest, by A.J. Finberg, was published in 1909 by the British Museum and many of his numberings have been used in this publication. A new inventory, by Andrew Wilton, is in the course of preparation.

SELECTED BIBLIOGRAPHY AND ABBREVIATIONS:

B.J.: Martin Butlin and Evelyn Joll, *The Paintings of J.M.W. Turner,* Vols. I and II, rev. ed., New Haven and London, 1984.

Butlin: Martin Butlin, "Turner's Late Unfinished Oils: Some new evidence for their late date," *Turner Studies,* Vol. I, No. 2, pp. 43-45.

Cormack: Malcolm Cormack, *J.M.W. Turner, R.A. 1775-1851, A Catalogue of Drawings and Watercolors in the Fitzwilliam Museum, Cambridge,* Cambridge, 1975.

Hill: David Hill, *In Turner's Footsteps,* London, 1984.

Manchester: *Turner at Manchester, a Catalogue Raisonné,* Manchester, 1982.

Rawlinson: W.G. Rawlinson, *The Engraved Work of J.M.W. Turner, R.A.,* 2 vols., London, 1908 and 1913.

Shanes (I): Eric Shanes, *Turner's Picturesque Views in England and Wales,* London, 1979.

Shanes (II): Eric Shanes, *Turner's Rivers, Harbours and Coasts,* London, 1981.

Shanes (III): Eric Shanes, "The true subject of a major late painting by J.M.W. Turner identified", *The Burlington Magazine,* May 1984, Vol. CXXVI, pp. 284-299.

T.B.: Turner Bequest, London.

Wilton: Andrew Wilton, *The Life and Work of J.M.W. Turner,* London, 1979. Where the name Wilton, followed by a number, appears in the category of 'Literature' in the catalogue entries, this refers to the numbers accorded to the respective watercolor by Wilton in this book. (An identical procedure is followed with the other books listed above, where relevant.)

A NOTE ON THE INSTALLATION OF THIS EXHIBITION:

One of the ancillary aims of this exhibition is to attempt a recreation of the kind of hanging that Turner would have known and welcomed for his watercolors. In his day the notion of hanging pictures fairly widely apart, with much vacant wall space between them, was almost unknown, especially for watercolors. In the Royal Academy and other public exhibitions, the pictures, both in oil and watercolor, were crowded together frame-to-frame, and artists, including Turner, would even adjust the colors and tones of their oil paintings at the last moment in order to take account of that fact. In private collections, Turner's watercolors were also hung closely together, as can be seen in John Scarlett Davis' watercolor of *The Library at Tottenham, the Seat of B.G. Windus, Esq., showing his collection of Turner watercolours* (British Museum, London; ill. 8), dating from 1835. (Windus was a retired coach-maker and collector who by 1840 owned upwards of 200 Turner watercolors and who commissioned the drawing from Davis to record their display.) Just as today much time and effort is expended upon the recreation of what are thought to be "authentic" performing practices in music, (i.e. the absence of vibrato, the use of original instruments, the playing of works without a conductor, and the like), it was felt worthwhile to try and recreate here a typical early nineteenth century close display of Turner drawings, especially in the environment of the Taft Museum which is one of the few major museums in the world which still enjoys the intimacy of a private house. ES

8 John Scarlett Davis, **The Library at Tottenham, the Seat of B.G. Windus, Esq., showing his collection of Turner watercolours**, *signed and dated 1835; watercolor and stopping-out and heightened with gum arabic, 29.2 x 55.8 cm., courtesy of the Trustees, British Museum, London.*

THE EXHIBITION CATALOGUE

Works not illustrated will be found as color plates.

1 INTERIOR OF KING JOHN'S PALACE, ELTHAM

Watercolor on white paper, 33.2 x 27 cm. *c.* 1793.

Prov.: H. Ferrar; Sotheby, 20 April 1972 (65); Cyril and Shirley Fry, from whom purchased, 1972.
Coll.: Yale Center for British Art, Paul Mellon Collection, New Haven.
Lit.: Wilton 13.

The Royal Palace at Eltham—a name derived from the words *eald ham* or "the old home or dwelling"—was frequently the principal residence of the kings of England from the time of King Henry III in the late thirteenth century to King Henry VIII, who in or around 1527 moved to a new palace at Greenwich. Eltham Palace became a farm after 1660, and its banqueting hall (depicted here by Turner) was turned into a barn. The building was heavily restored around the turn of this century and is now leased to the British Army. It was not built by King John, but probably received its name from association with a son of King Edward II, called John of Eltham, who was born there.

Turner's use of washing and rubbing-out to obtain the effect of brilliant sunlight entering the dark interior from the left is discussed more fully in the main text.

2 THE ANGLER

Signed and dated on verso: *Turner 1794.*
Pen and watercolor on white paper, 22.9 x 15.4 cm.

Prov.: Andrew Caldwell; H.E. Ten Cate, sale, Sotheby, 10 December 1958 (98), bt. Rubinstein; sale, Sotheby, 29 November 1973 (89), bt. Agnew, from whom purchased.
Coll.: Yale Center for British Art, Paul Mellon Collection, New Haven.
Lit.: Wilton 85.

This vivacious work may have been made for engraving as an illustration but not subsequently used: representations of peop-

2 THE ANGLER, 1794. Yale Center for British Art, Paul Mellon Collection; New Haven, Connecticut.

le, where the landscape plays a subsidiary role, are unusual outside of Turner's illustrative work. The picture enjoys an excellent linear coherence, with the fishing rod carrying the line of the river bank over to the right and, in doing so, knitting the top and bottom halves of the work together. What the drawing lacks in representational terms, being somewhat sketchy in parts, it certainly makes up for in spontaneity.

3 INSIDE OF TINTERN ABBEY, MONMOUTHSHIRE

Watercolor on white paper, 32.1 x 25.1 cm. 1794.

Exh.: Royal Academy, 1794 (#402).
Prov.: possibly John Green of Blackheath, sale, Christie's, 24 April 1830 (5), bt. Hixon; W. Smith; by whom given to the museum, 1871.
Coll.: Victoria and Albert Museum, London.
Lit.: Wilton 57.

Tintern Abbey was a Cistercian house founded in 1131 during the reign of Henry I, and it was destroyed during the Reformation. The abbey stands in a particularly lovely stretch of the Wye Valley. Turner sketched the site on his first tour of Wales in 1792, recording this view on a sheet still in the Turner Bequest (T.B. XII-E). He also made a second version of the same view (T.B. XXIII-A) which is not quite complete and which was probably a preparatory study for this drawing. For discussion of Turner's depiction of the architecture and compositional ingenuity in this work, see the main text.

4 CHRIST CHURCH, OXFORD

Signed and dated lower right: *Turner 1794.*
Pencil and watercolor on white paper, 39.5 x 32 cm.

Prov.: with Messrs. Thomas McLean, Haymarket; the Rev. E.S. Dewisk; given to museum by Mrs. E.S. Dewisk, 1918.
Coll.: Syndics of the Fitzwilliam Museum, Cambridge.
Lit.: Cormack 4, Wilton 72.

Turner probably first visited Oxford during his childhood since he had an uncle who lived nearby at Sunningwell. Certainly he

was far more attracted to Oxford than he ever was to Cambridge: eventually he produced over 26 highly finished watercolors and two oils of Oxford subjects but he left only about five watercolors of Cambridge scenes (four of which are now untraced). Of the 26 Oxford views, no less than 11 are depictions of Christ Church and include four representations of the cathedral part of the college. In this watercolor the artist depicts a view of the cathedral on a fine summer's evening with the light casting long shadows across the greensward and a gowned academic lost in his book.

5 THE 'HEART OF OAK' INN, *c.* 1792-94. City Art Gallery, Manchester.

5 THE 'HEART OF OAK' INN

Pencil and watercolor on white paper,
25.7 x 20.3 cm. *c.* 1792-94.

Prov.: H.G. Spicer, sale, Christie's, 8 December 1922 (51), bt.
Brockbank; G. Beatson Blair, by whom bequeathed to the
gallery, 1941.
Coll.: City Art Gallery, Manchester.
Lit.: Manchester I; not in Wilton.

This watercolor is very probably a "Monro School" copy and
could be after a work by Edward Dayes. The precise location
of the subject remains unidentified. For a discussion of the
work, see the main text.

6 TONBRIDGE CASTLE, KENT

Pencil and watercolor on white paper,
19.8 x 27.7 cm. *c.* 1794.

Prov.: John Ruskin; passed to Arthur Severn, at Brantwood,
sold, Sotheby, 20 May 1931 (117), bt. Friends of the

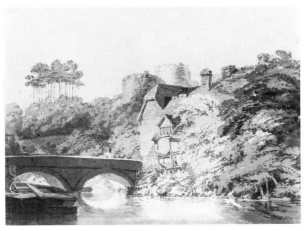

6 TONBRIDGE CASTLE, KENT, *c.* 1794. The Fitzwilliam
Museum, Cambridge.

Fitzwilliam Museum, by whom given to the museum.
Coll.: Syndics of the Fitzwilliam Museum, Cambridge.
Lit.: Cormack 3, Wilton 112 (?).

Critical opinion has divided over the attribution of this
drawing, ascribing it to Thomas Girtin and Edward Dayes,
while the design may have derived from a drawing by Paul
Sandby or even originally have been by John Henderson, Dr.
Monro's neighbor at Adelphi Terrace. However, it certainly
seems likely that it is a "Monro School" copy and that Turner
might well have washed in the effects after Girtin had drawn
the outlines. For a discussion of the work see the main text.

Tonbridge Castle, overlooking the river Medway,
originally dated from the end of the thirteenth century but was
extensively rebuilt at the end of the eighteenth century.
However, the two semicircular fronted towers were allowed to
remain and do so to this day. The picturesque cottage below
the castle appears to have been demolished in 1793, which is
perhaps not surprising, given the way it was evidently falling
down at the time.

7 FRESHWATER BAY, ISLE OF WIGHT

Pencil and watercolor on white paper, 19.5 x 26 cm. *c.* 1795.

Prov.: T.W. Bacon, by whom given to the museum, 1950.
Coll.: Syndics of the Fitzwilliam Museum, Cambridge.
Lit.: Cormack 5, Wilton 178.

Turner probably toured the Isle of Wight off the southern coast
of England in August or September, 1795, when he was twenty.
This drawing is rather similar to a partially colored line drawing
on page 39 of the sketchbook that he took along on the tour
(T.B. XXIV), although instead of a windlass placed on the
beach at the bottom right, Turner here locates an overturned
boat in that position. The net-poles—used for drying nets—are
evident in both works.

It has been thought that Turner developed this drawing
from the sketchbook study. However, a comparison of the two
works shows that whereas the sea and the cliff in the sketch-
book are depicted with, respectively, a real grasp of wave
motion and geological formation, such handling is much less
the case in the present work. It would seem likely, therefore,

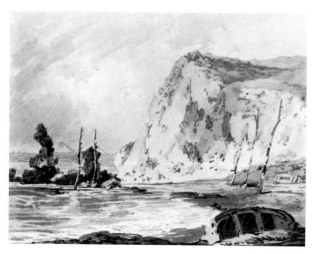

7 FRESHWATER BAY, ISLE OF WIGHT, *c.* 1795. The Fitzwilliam Museum, Cambridge.

that the present drawing may date from *before* Turner made his Isle of Wight tour and, indeed, it may be yet another "Monro School" copy even though it does correspond in size to commissioned watercolors which resulted from the tour. Certainly it displays a slight carelessness in the use of washes and the same blue-gray coloring and handling that are commonly encountered in "Monro School" copies. It would not have been unusual for Turner, when visiting the Isle of Wight, to seek out and draw directly a landscape he had previously only encountered at one remove in a copy.

8 ROCHESTER, KENT

Signed bottom right: *W. Turner 1795.*
Pencil and watercolor on white paper, 22.8 x 30.3 cm.

Prov.: Adam Fairrie, sale, Christie's, 16 March 1861 (87); Wallis & Son, the French Gallery; bt. James Blair, 30 November 1912, by whom bequeathed to the gallery, 1917.

Coll.: City Art Gallery, Manchester.
Lit.: Manchester 2, Wilton 129.

This drawing, which is in a superb condition, depicts the view looking from the main London road above Strood across the old bridge and Rochester toward Chatham in the far distance on the left. There the dockyards and barracks are clearly visible, along with several naval vessels in the river Medway. The depiction of Rochester is especially fine, with the Norman castle and cathedral glistening brilliantly in the late afternoon sunlight and enjoying the lightest tonal rendering in the entire work. By this means Turner not only leads our eye to the most important buildings in the scene, but also suggests the precise degree of moisture in the air. The trees on the right act both as a framing device somewhat in the manner of Claude and add equally to the sense of distance and the feeling of immateriality in the buildings far beyond. Turner returned to this viewpoint in a drawing made some 41 years later for engraving in the "England and Wales" series, where the vista encompasses more of the landscape to the left. (That watercolor was unfortunately destroyed by fire in 1955; the engraving, however, serves to remind us of its appearance.)

9 PEMBURY MILL, NEAR TUNBRIDGE WELLS, KENT

Signed lower right: *W. Turner* *c.* 1795-96.
Pencil and watercolor on white paper, 20.3 x 27.7 cm.

Prov.: Unknown.
Coll.: Victoria and Albert Museum, London.

Turner made two watercolors of this mill. The other drawing, which is more highly detailed (but unsigned), is in the collection of the British Museum. That drawing not only shows to the left of the millwheel an additional stretch of river which is in spate, but also has a cart and horses passing across a bridge over the water. Here, however, Turner is in a calmer mood, with a man—who is surely the miller—and a girl apparently taking their ease, a detail which suggests that we are looking at an evening scene. For further discussion of this drawing, see the main text.

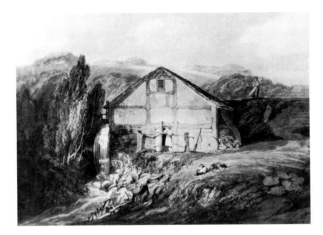

9 PEMBURY MILL, NEAR TUNBRIDGE WELLS, KENT, *c.* 1795-96. Victoria and Albert Museum, London.

10 THE CASCADES, HAMPTON COURT, HEREFORDSHIRE

Signed and dated lower right: *W. Turner 1795,* also signed lower left.
Pencil and watercolor with some bodycolor on white paper, 31.4 x 41.1 cm.
Prov.: Viscount Malden, later fifth Earl of Essex; William Smith, by whom given to the museum, 1871.
Coll.: Victoria and Albert Museum, London.
Lit.: Wilton 186.

Hampton Court, near Hereford, in the west of England (not to be confused with Hampton Court Palace, the royal residence just outside London), was the principal seat of Viscount Malden, later fifth Earl of Essex, who commissioned five watercolors of the house and grounds in 1795. The subject of this work was one of those stipulated, and a later view of the house itself is also included in this exhibition (#25). The later work, however, was commissioned by another of Turner's early patrons, Sir Richard Colt Hoare.

Volume 6 of Britton and Brayley's *Antiquities of England and Wales,* published in 1805 and to which Turner contributed a view of the south front of Hampton Court, Herefordshire, for engraving as its frontispiece, tells us: "During the floods which frequently occur here in a rainy season, a fine cascade is formed by the rushing of the water over a mass of broken rock". Turner's fine depiction of these rushing waters is based upon a pencil drawing still in the Turner Bequest (page 50 of the *South Wales* sketchbook, T.B. XXVI) and is discussed in the main text.

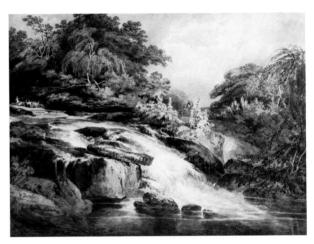

10 THE CASCADES, HAMPTON COURT, HEREFORD-SHIRE, 1795. Victoria and Albert Museum, London.

11 VIEW ON THE SUSSEX COAST

Pencil and watercolor on paper, 39.5 x 50.5 cm. *c.* 1796.
Prov.: Christie's, 1907 (as "Rottingdean"), bt. Palser; bt. by the Friends of the Fitzwilliam, by whom given to the museum, 1913.
Coll.: Syndics of the Fitzwilliam Museum, Cambridge.
Lit.: Cormack 6, Wilton 148.

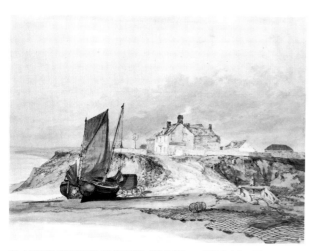

11 VIEW ON THE SUSSEX COAST, *c.* 1796. The Fitzwilliam Museum, Cambridge.

the left as it does between Brighton and Worthing in reality (the coastline between Rottingdean and Brighton is straight and mainly takes the form of cliffs). Moreover, the two boats drawn up on the beach at the left are recognizable as Brighton hoggies, or hog-boats, a local kind of sprit-rigged, wide-beamed, and shallow-draught fishing trawler used to fish the extremely shallow waters off the town (and a type of boat which was never found anywhere else). Futhermore, just to the right of the hoggies is a bathing machine, another indication that we are, in fact, looking at a Brighton view, for such machines were much more likely to be seen at Brighton than at Rottingdean since Brighton was already being used for sea-bathing at the end of the eighteenth century. Turner also supplies other local details, including trawling nets, lobster pots, and a windlass which was used for pulling boats ashore. If this watercolor is indeed a portrayal of the Ship Inn in Brighton, then it represents the view from the same spot but looking in the opposite direction from where Turner derived the picture of Brighton which is discussed next.

In 1796 Turner probably visited Brighton, located on the south coast of England about 60 miles south of London. At the time it was only a small fishing village although later, during the Regency, it would become a very fashionable town. This work and the drawing known to represent Brighton which is also included in this exhibition (#12), almost certainly resulted from that possible trip.

There has been some conjecture over the precise location of the subject of this watercolor, and Malcolm Cormack, in his catalogue of the Fitzwilliam Museum's collection of Turner watercolors, has suggested that it shows a view of Rottingdean, a small fishing village about two miles to the east of Brighton. However, that cannot be the case since the land is far too low in Turner's drawing for it to represent Rottingdean. Instead, a clue to the precise location of the scene resides in the inn sign at the center. This sign depicts a ship, and the inn may therefore easily be the Ship Inn (now the Old Ship Inn), a famous hostelry founded around 1600 which still stands, albeit in modernized form, on the sea front at Brighton. Other details also support this hypothesis. For example, the low coastline curves away on

12 BRIGHTHELMSTONE

Pencil and watercolor on white paper,
40.7 x 54.1 cm. *c.* 1796.

Prov.: John Heugh.
Coll.: Victoria and Albert Museum, London.
Lit.: Wilton 147.

Here there is no doubt that this watercolor is a view of Brighton for, in addition to writing the name "HOPE of Brighton" on a boat on the left, we can easily recognize the view looking eastward toward the chalk cliffs stretching away to Rottingdean, Newhaven, and Beachy Head, with the area of seafront known as the Fishermen's Steps on the left. Turner obviously liked the anachronistic name of Brighton for when in 1824 he made another view of the town for engraving in the "Southern Coast" series he named the drawing and engraving "Brighthelmstone."

Turner's superb rendering of the waves and his tonal control in this drawing are discussed in detail in the main text.

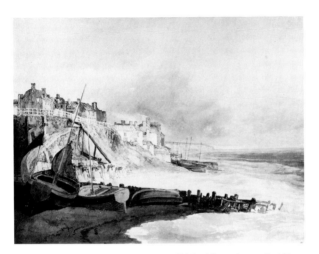

12 BRIGHTHELMSTONE, *c.* 1796. Victoria and Albert Museum, London.

the positive dynamic quality he imparts here is something that was far beyond Hearne's powers.

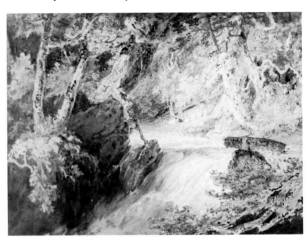

13 A RIVER IN SPATE, *c.* 1796. City Art Gallery, Manchester.

13 A RIVER IN SPATE

Pencil and watercolor on white paper,
35.5 x 49.5 cm. *c.* 1796.

Prov.: John Knowles (?); Agnew, November 1865, sold to J.E. Taylor as "waterfall" (?); J.E. Taylor, sale, Christie's, 5 July 1912 (94), bt. Agnew; from whom bought by Dr. David Lloyd Roberts, 16 July 1912; his bequest to the gallery, 1920.
Coll.: City Art Gallery, Manchester.
Lit.: Manchester 3, Wilton 175.

The precise location of the subject of this work has not been identified, but Turner certainly invests the whole scene with a relentless sense of energy. He achieves this energy by means of a multitude of dots of watercolor and a rhythmic flow that is as evident in the tree trunks and foliage as it is in the depiction of the water. The sense of energy in the trees may be something that Turner developed under the influence of the restless quality which is apparent in Hearne's depictions of foliage, although

14 A GREAT TREE

Pencil and watercolor on white paper,
25.2 x 38.6 cm. (a narrow strip of paper
added along bottom edge). *c.* 1796.

Prov.: W. Parker; by descent to Capt. Parker, sale, Sotheby, 12 December 1928 (59), bt. L.G. Duke; from whom bt. Paul Mellon, 1961.
Coll.: Yale Center for British Art, Paul Mellon Collection, New Haven.
Lit.: Wilton 157.

Gnarled beech trees were instantly attractive as picturesque objects to artists around the end of the eighteenth century and it was inevitable that Turner, with his pronounced sense of the character in a landscape, should have been drawn to representing them. Around 1796 he spent some time on the estate of the scholar and collector William Lock of Norbury Park, Surrey, and there he made several watercolors of beech trees. This

work may have been one of them. However, as suggested in the main text, the artist's intense responsiveness to the underlying dynamics of sylvan form is already becoming apparent, and it gives the tree a sense of organic coherence. The figures, however, are totally out-of-scale—if they were true to scale the size of each leaf would be bigger than a human head—and they have evidently been introduced to enhance the scale of the tree. Here, as elsewhere, we can see Turner's predilection for the augmentation of scale at work, even in representations of picturesque objects.

15 NEWARK-UPON-TRENT CASTLE

Inscribed on verso: *Newark-upon-Trent/J. M. W. Turner.*
Pencil and watercolor on white paper,
30.3 x 42.1 cm. *c.* 1796.
Prov.: P.R. Bennett; bt. Agnew, 1971.
Coll.: Yale Center for British Art, Paul Mellon Collection, New Haven.
Lit.: Wilton 168.

Newark-upon-Trent is situated some 16 miles northeast of Nottingham in the Midlands of England at a point where the Nottingham-Lincoln Road crosses the Great North Road. It was therefore once strategically important for it commanded the approaches to and from the north of England. Newark Castle, dating from 1123, replaced an earlier castle on the same site. King John died there in 1216, and it was reduced to a shell during the Civil War in 1646. By Turner's day the interior was used as a cattle market with a coal wharf on the river frontage. The wall that Turner depicts is still standing, although in an even more ruinous state than it was around 1796. The artist visited Newark on his first Midland tour in 1794 and drew the castle from a more distant viewpoint than the one represented in this watercolor; he may, however, have used that drawing (T.B. XXII-G) as the basis of this work, adding details such as the broken boat on the banks of the Trent.

For further discussion of Turner's employment of association to heighten the moral undertones in this picture see the main text.

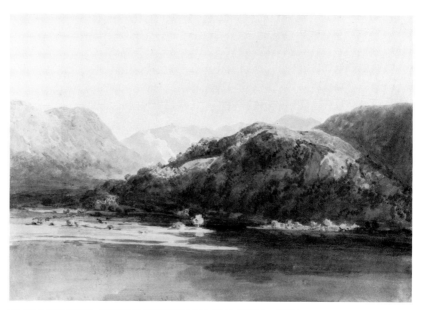

16 ULLSWATER, WITH PATTERDALE OLD HALL, 1797.
The Fitzwilliam Museum, Cambridge.

16 ULLSWATER, WITH PATTERDALE OLD HALL

Inscribed by Turner on verso in ink: *Patterdale Grange (?) of Patterdale...(?).*
Pencil and watercolor on cream paper,
25.8 x 37.1 cm. 1797.
Prov.: Edward Fox White, sale, Christie's, 12 December 1862 (80), bt. Crofts; Cotswold Gallery, 1926, Sir Sydney Cockerall; given by Friends of the Fitzwilliam, 1926.
Coll.: Syndics of the Fitzwilliam Museum, Cambridge.
Lit.: Cormack 8, Wilton 228.

This drawing possibly once formed part of the *Tweed and Lakes* sketchbook (T.B. XXXV), used by Turner on a tour of the Lake District in 1797. The sketchbook contains similar pencil

and watercolor studies of Ullswater and Patterdale on pages 44 and 45.

Ullswater is one of the loveliest of the English lakes. Turner certainly responds to that beauty, rendering the afternoon light with complete assurance and subtly making the Old Hall, which was rebuilt around 1800 and is now an hotel, into the pictorial focal point.

17 KIRKSTALL ABBEY, YORKSHIRE

Watercolor on white paper, 51.4 x 74.9 cm. 1798.

Prov.: "Hon. Mr. Lascelles" (Edward, Lord Harewood), for whom painted; by descent to the fourth Earl of Harewood; his sale, Christie's, 1 May 1858 (47), bt. Townend; Mrs. Townend, her sale, Christie's, 2 July 1887 (76), bt. Polak; the Rev. E.S. Dewick; Mrs. E.S. Dewick, by whom given to the museum, 1918.
Coll.: Syndics of the Fitzwilliam Museum, Cambridge.
Lit.: Cormack 7; Wilton 224; *Turner in Yorkshire* by David Hill, York, 1980, #18, p. 23; "A Taste for the Arts: Turner and the Patronage of Edward Lascelles of Harewood House" by David Hill, *Turner Studies,* Vol. 4, No. 2, Winter 1984, pp. 24-33 and Vol. 5, No. 1, Summer 1985, pp. 30-46.

The Lascelles family of Harewood House in Yorkshire were important patrons of Turner between 1796 and 1808-09. They eventually owned 11 impressive watercolors and two oil paintings by him. This particular work was one of five paid for by Edward, Lord Harewood, on 15 March 1798 and probably dates from that year even though the literature on Turner prior to that of David Hill given above ascribes the work to 1797.

Kirkstall Abbey was a Cistercian monastery founded in the twelfth century and destroyed during the Reformation. Turner portrayed the abbey three times in all. He based this particular work upon a detailed study on page 16 of the *North of England* sketchbook (T.B. XXXIV), used on his first tour of the North Country in 1797. In the picture we view the abbey from the southeast across the weir on the river Aire which again appears in both of his later watercolors of the building. As elsewhere he exaggerates, in this case the height of the tower in

17 KIRKSTALL ABBEY, YORKSHIRE, 1798. The Fitzwilliam Museum, Cambridge.

relation to its true height which is established in his original sketch. The mood of the work is one of calm lyricism and throughout Turner provides an especially fine detailing of the flow of water, reflections on the river, and vegetation. Again the reservation of the areas of highest tone for the principal topographical features of the view can easily be observed.

18 KILGARREN CASTLE, PEMBROKESHIRE

Signed bottom left: *W. Turner*
Watercolor on white paper, 26.7 x 36.5 cm. *c.* 1798.

Prov.: John Ruskin; Arthur Severn; Maxwell Reekie; Agnew, 1924; G. Beatson Blair, 1924, by whom bequeathed to the gallery, 1941.
Coll.: City Art Gallery, Manchester.
Lit.: Manchester 4, Wilton 243.

Cilgerren Castle, in Pembrokeshire, Wales, dates from after 1223 when it was rebuilt by the Earl of Pembroke who used it to control the Welsh. It dominates the river Teifi and Turner represented it from this exact spot in both an oil painting exhibited at

the Royal Academy in 1799 and another watercolor made for engraving in the "England and Wales" series some 25 or so years after this work. In each of those pictures he depicts the early morning sunlight bursting forth from near or behind the castle, but here he portrays the building in early afternoon light and is content to express a less dynamic response to the scene.

The watercolor is based upon a study made on page 88 of the *Hereford Court* sketchbook (T.B. XXXVIII) used in 1798 on Turner's fourth tour of Wales. The diagonals of the near and far banks of the river Teifi lend pictorial unity to the work while enhancing the sense of dominance of the castle. The variation of both tone and a restricted range of colors in the work is particularly impressive.

18 KILGARREN CASTLE, PEMBROKESHIRE, *c.* 1798. City Art Gallery, Manchester.

19 WARKWORTH CASTLE, NORTHUMBERLAND—THUNDER STORM APPROACHING AT SUN-SET

Watercolor on paper, 52.1 x 74.9 cm. 1799.

Exh.: Royal Academy, 1799 (#434); W.B. Cooke gallery, 1824 (#24), lent by Messrs. Hurst and Robinson.
Eng.: by T. Lupton (as *Warkworth Castle, on the river Coquet*) for "The Rivers of England" series, 1826.
Prov.: with Messrs. Hurst, Robinson & Co., 1824; Ellison, by whom given to the museum.
Coll.: Victoria and Albert Museum, London.
Lit.: Wilton 256; Shanes (II) 1.

When this impressive watercolor was first exhibited at the Royal Academy in 1799 its title was accompanied in the exhibition catalogue by these lines from James Thomson's poem, "The Seasons:"

> Behold slow settling o'er the lurid grove,
> Unusual darkness broods; and growing, gains
> The full possession of the sky; and yon baleful cloud
> A redd'ning gloom, a magazine of fate
> Ferment....

> ("Summer," lines 1103-06, 1111-13)

Quite evidently Turner employed this quotation in order to introduce an extra dimension to his picture, namely that of time, for the verse tells of things to come in a way that the picture alone can barely hint at. Certainly the artist represents the still before the storm, with fishermen working at last light on the river Coquet and a small pall of smoke indicating the direction of the wind. But in order to extend the work imaginatively beyond the single moment he represents he had to elicit the aid of words, and in this case a poetry rich in metaphorical meaning. In other works exhibited at the Royal Academy in the same year he also moved the viewer beyond the pictorial moment with a quotation from Milton's *Paradise Lost* which was linked to the title of a picture of Harlech Castle, introduced associations of another sensation not available to a painter, namely sound, in a quotation also taken from *Paradise Lost*, and employed a quotation from a poem by Samuel Langhorne to add a wholly allegorical dimension to a picture of what was probably a morning landscape. (This latter work has totally disappeared, and now we have no way of knowing what it looked like.)

Turner based this watercolor upon a line drawing on page 40 of the *North of England* sketchbook (T.B. XXXIV) used on his tour of the North Country in 1797. He later allowed the

design to be reproduced as a mezzotint engraving (titled *Warkworth Castle, on the River Coquet*) in "The Rivers of England" series, where it was published in 1826.

20 GATEWAY TO THE CLOSE, SALISBURY

Signed lower right: *J. M. W. Turner R.A.*; and inscribed on verso in pencil, possibly in Turner's hand: *S R Hoare Bart/ Salisbury [?] & Hampton.*
Watercolor on paper, 45.6 x 31.5 cm. *c.* 1802.

Prov.: Sir Richard Colt Hoare; Sir Henry Hoare; sale, Christie's, 30 July and 4 and 7 August 1883 (in a volume), bt. the Rev. J.H. Ellis; H.A. Stewart, sale, Christie's, 28 July 1927 (2), bt. Leggatt; P.C. Manuk and Miss G.M. Coles, by whom bequeathed to the museum through the National Art Collections Fund, 1948.
Coll.: Syndics of the Fitzwilliam Museum, Cambridge.
Lit.: Cormack 11, Wilton 208.

Turner appears to have been commissioned to make 20 watercolors by the banker and collector, Sir Richard Colt Hoare, although not all of them were necessarily produced. These works date from between 1796 and 1806. The artist created two or possibly even three views of Salisbury Cathedral Close. One of them was certainly exhibited at the Royal Academy in 1796, although it could not have been this picture since the addition of the letters "R.A." to Turner's signature informs us that the drawing dates from after the artist's election as a full Academician in February, 1802.

The watercolor was based upon an outline drawing in pencil on page 16 of the *Isle of Wight* sketchbook of 1795 (T.B. XXIV). It has a curiously old-fashioned look as a result of the treatment of the picturesque buildings in the Close, which look like Turner could have painted them a decade earlier than 1802. However, such a rendering serves to offset the impressive scale and majesty of the cathedral spire beyond. This is identical in treatment to the depiction of the spire in the other drawing of Salisbury Cathedral in this exhibition (#21), a work that probably dates from 1802. Moreover, the detail of a small boy playing with a hoop, who is seen here on the left and who similarly appears in the other work, also suggests that both watercolors may date from around the same time.

20 GATEWAY TO THE CLOSE, SALISBURY, *c.* 1802. The Fitzwilliam Museum, Cambridge.

21 SOUTH VIEW FROM THE CLOISTERS, SALISBURY CATHEDRAL

Signed on a flagstone at lower left: *J. M. W. Turner R.A.*
Pencil and watercolor on white paper, 68 x 49.6 cm. *c.* 1802.

Prov.: Sir Richard Colt Hoare; by descent, Sir Henry Hoare, sale, Christie's, 2 June 1883 (21); bt. Agnew.
Coll.: Victoria and Albert Museum, London.
Lit.: Wilton 202.

This is one of Turner's most stunning compositions: the broken trefoil tracery within a pointed arch, combined with a section of quatrefoil tracery at the top right, form a framing device of unusual inventiveness which serves by contrast to add an immense sense of scale to the already vast building seen beyond them. Turner wittily plays up the circular rhythms that dominate the top of the picture by making the boy in the foreground spin a small top in his hand. Far from diminishing the seriousness of the work, however, the playful boy enhances it by projecting a moral dimension encountered elsewhere in Turner's art: children play among churches and tombs, seemingly unaware of the ultimately serious implications of their surroundings. This circularity is also augmented by the hoop on the left, the handle of a basket above it, and the hoop that is being held by a gowned figure (who is perhaps a chorister) in the distance. Turner's grasp of the complexities of Gothic architecture is total. The play of light within the shadows, the brilliance and variety of reflections across the sun-lit surfaces, and the sense of space all serve to project the cathedral in a way that is truly monumental.

22 INVERARY, LOCH FYNE

Signed lower left: *JMW Turner RA.*
Watercolor on white paper, 21 x 29.5 cm. *c.* 1803.
Eng.: by J. Heath for Mawman's *Excursion to the Highlands of Scotland and the English Lakes,* 1805 (R. 73).
Prov.: Colnaghi; Agnew, 1863; P. Allen, sale, Christie's, 6 March 1869 (36), bt. Agnew; S.J. Stern; Mrs. Stern, sale, Christie's, 19 June 1908 (53), bt. Vicars; bt. Agnew, 1908; James T. Blair, by whom bequeathed to the gallery, 1917.
Coll.: City Art Gallery, Manchester.
Lit.: Manchester 6; Wilton 352; Edward Yardley, "Picture Notes", *Turner Studies,* Vol. 5, No. 2, Winter 1985, pp. 54-56.

22 INVERARY, LOCH FYNE, *c.* 1803, City Art Gallery, Manchester.

Turner based this drawing on a pencil sketch made during his first tour of Scotland (*Scottish Pencils,* T.B. LVIII-10). The watercolor formed part of what was intended to be a set of four works illustrating a book by Joseph Mawman entitled *Excursion to the Highlands of Scotland and the English Lakes* which was published in 1805. Turner only completed three of the designs and was paid 20 guineas for them.

The view represents Inverary as seen from the south, looking toward Duniquoich Hill on the right and Inverary Castle, the home of the Dukes of Argyll, in the distance at its foot. The steeple of the new church by Robert Mylne can be seen still under construction. Turner also accurately represents the local herring-buses or speedy, lightweight skiffs which were used to fish the stormy waters of Lochs Fyne and Shira, with a recent catch being unloaded.

23 RIVER SCENE, WITH A BRIDGE IN THE DISTANCE

Watercolor and oil on paper, 22.5 x 29.5 cm. *c.* 1806.
Prov.: T.W. Bacon, by whom given to the museum, 1950.

Coll.: Syndics of the Fitzwilliam Museum, Cambridge.
Lit.: Cormack 12, Wilton 418.

Although it has been suggested that this is a view on the river Usk in Wales, there is no evidence to support that view, and nor is there any information to validate the contention that the work was made in 1808 when Turner was staying at Tabley Hall in

23 RIVER SCENE, WITH A BRIDGE IN THE DISTANCE, *c.* 1806. The Fitzwilliam Museum, Cambridge.

Cheshire. (Because of some superficial similarities in technique, it has been maintained that Turner perhaps painted this picture on an excursion from Tabley, possibly into Lancashire.) The presence of oil paint alongside the watercolor suggests that the work instead dates from the same time that Turner was using a boat as a floating studio with which to explore the reaches of the upper Thames valley, possibly around 1806. The picture enjoys a degree of spontaneity strongly reminiscent of that found in studies either definitely or probably made on the Thames, and Turner would hardly have been likely to have taken oil paints along on a brief excursion into Lancashire. The precise location of the subject remains a mystery, however. Nonetheless it is a very lovely picture, in which Turner's han-

dling of paint, use of the wooden end of the brush to scratch out lines and forms, and sensitive palette totally convey the sense of movement in the landscape and reflections on the water, while simultaneously communicating a profoundly lyrical response to the scene.

24 LANDSCAPE WITH TREES BY A RIVER

Pencil and watercolor on paper, 23.5 x 35.6 cm. *c.* 1806.

Prov.: Dr. David Lloyd Roberts, by whom bequeathed to the gallery, 1920.
Coll.: City Art Gallery, Manchester.
Lit.: Manchester 7, Wilton 412.

Again the fluency of handling and freshness of response suggest that this watercolor was actually made on the spot rather than in the studio. Although the subject remains uncertain, it has been suggested that the work may represent Petersham, near Richmond in Surrey, where the church has a tower capped by a lantern, as does the church seen on the right here. However, that hypothesis is unlikely to be the case since if it were Petersham one would expect to see Richmond Hill immediately behind it and the river in the distance would bend around toward the left instead of to the right.

25 HAMPTON COURT, HEREFORDSHIRE, SEEN FROM THE SOUTH-EAST

Watercolor on white paper, 20.2 x 30.5 cm. *c.* 1806.

Prov.: Sir Richard Colt Hoare; by descent to Sir Henry Hoare, sale, Sotheby, 30 July 1883 (450); Coningsby Disraeli; Colnaghi, from whom purchased, 1971.
Coll.: Yale Center for British Art, Paul Mellon Collection, New Haven.
Lit.: Wilton 216.

Hampton Court was built during the reign of King Henry IV by one of his court favorites, Sir Rowland Lenthall, the Yeoman of

25 HAMPTON COURT, HEREFORDSHIRE, SEEN FROM THE SOUTH-EAST, *c.* 1806. Yale Center for British Art, Paul Mellon Collection; New Haven, Connecticut.

the Robes, who acquired his wealth by ransoming his prisoners after the battle of Agincourt. As stated above (see #10), it was the principal seat of Viscount Malden, later fifth Earl of Essex, one of Turner's early patrons. This particular work, however, was commissioned by Sir Richard Colt Hoare, who also ordered the Salisbury drawings (#20 and #21) from Turner. The artist made two versions in watercolor of this particular view of the house; he based them both upon the same sketch on page 51 of the *South Wales* sketchbook (T.B. XXVI) used in 1795 on his third tour of the marches and Wales. The first watercolor (Wilton 98) is now lost, but it was subsequently engraved. The present picture clearly represents a great advance in terms of design, however, with its unforced lyricism and inventive diversity of forms, particularly at the lower right where Turner's scratching-out may also easily be seen. This area of formal complexity completely offsets any sense that the building is foursquare, and indeed contributes a vitality that was often missing from country house views by other, lesser artists of the time. Turner's total grasp of the welling of water in the river Lugg is also very apparent.

26 ADDINGHAM MILL ON THE WHARFE, WEST YORKSHIRE

Pencil and watercolor on white paper,
27.3 x 38.7 cm. *c.* 1808.

Eng.: J.C. Allen, unpublished (R. 168).
Prov.: Walter Fawkes, Farnley Hall (?); J.E.Taylor, his sale Christie's, 5 July 1912 (54), bt. Agnew, from whom bt. H.J. Mullen, 13 December 1912; James Blair, by whom bequeathed to the gallery, 1917.
Coll.: City Art Gallery, Manchester.
Lit.: Manchester 8, Wilton 548.

Addingham Mill still stands on the river Wharfe between Bolton Abbey and Ilkley. Turner probably visited the spot on a tour of this part of Yorkshire in 1808 when possibly he also stayed at Farnley Hall, the home of Walter Fawkes, who would later prove to be his greatest friend among his patrons. Although this work has been dated both by Wilton and Manchester to around 1815, the drawing of the trees does not enjoy anything of the degree of sophistication that Turner had evolved in his rendering of such forms by that time. Instead, it shares characteristics seen in his sylvan representations of around

26 ADDINGHAM MILL ON THE WHARFE, WEST YORK-SHIRE, *c.* 1808. City Art Gallery, Manchester.

1808. It is on that basis that the work has been re-dated here.

This is another of Turner's more lyrical and idealized landscapes, in which the artist seems content to respond to the beauty of a place rather than attempt any elaboration of its wider social implications. The children just standing or resting in the foreground add subtly to the overall mood of peaceful relaxation.

27 CHATEAU DE RINKENBERG, ON THE LAC DE BRIENTZ, SWITZERLAND

Signed and dated lower right: *JMW Turner RA PP 1809.*
Watercolor on white paper, 28.1 x 39.4 cm.

Exh.: Grosvenor Place, 1819 (#32).
Prov.: W. Fawkes; J. Ruskin, sale, 15 April 1869 (40), bt. Agnew; sold to John Heugh, sale, 24 April 1874 (90), bt. Agnew; sold to T.S. Kennedy, sale, Christie's, 18 May 1895 (92), bt. H. Quilter; Scott and Fowles, New York; Charles P. Taft.
Coll.: The Taft Museum, Cincinnati.
Lit.: Wilton 388.

In 1802 the cessation of hostilities between Britain and France allowed Turner to travel to Switzerland for the first time. This work was therefore based upon drawings made nearly seven years earlier. They appear on page 46 of the *Grenoble* sketchbook (T.B. LXXIV) and pages 17a and 23a of the *Rhine, Strassburg and Oxford* sketchbook (T.B. LXXVII). The sketch on page 17a of the latter book is actually inscribed *Ringenberg.*

The castle of Ringgenberg dates from the twelfth century and was converted into a church during the seventeenth century. It stands on the northern shore of Lake Brienz near its southern end; Unterseen and Interlaken are situated just beyond the spur jutting out into the lake. Turner delights in the midday sunlight which creates a multitude of tiny highlights, and in the shadows cast by the castle and church.

28 MER DE GLACE, IN THE VALLEY OF CHAMOUNI, SWITZERLAND

Watercolor and scraping-out on white paper,
28 x 39.4 cm. *c.* 1809.

Exh.: Grosvenor Place, 1819 (#24); Leeds, 1839 (#60 or #65).
Prov.: Walter Fawkes; Humphrey Roberts; Scott and Fowles, New York; Charles P. Taft.
Coll.: The Taft Museum, Cincinnati.
Lit.: Wilton 389.

This drawing is very similar to an impressive watercolor now in the Yale Center for British Art, New Haven, Connecticut (Wilton 365), which shows the same vista and dates from around 1815. In both works Turner represents the view looking eastward toward the group of mountains around the 13,000-foot-high Aiguille Verte and the vast glacier above Chamonix on the north side of the Mont Blanc massif.

In the present watercolor Turner uses a great deal of scraping- and stopping-out, and there is a superb energy in both the landscape depicted, with its threatening storm clouds, and in the way that the artist goes about creating that depiction. The dark mass on the right and the broken verticals at the center serve to project us into the vast empty space to the left and heighten the overall sense of immensity beyond. The feeling of impending danger in the landscape is intensified by the shepherds blowing a horn and waving their arms to frighten the sheep into safer pastures below.

29 WEYMOUTH, DORSETSHIRE

Signed lower right: *JMW Turner RA.*
Watercolor and scraping-out on white paper,
14 x 21.3 cm. *c.* 1811.

Eng.: by W.B. Cooke for the "Picturesque Views on the Southern Coast of England" series, 1814 (R. 91).
Prov.: George Cooke, 1822; B.G. Windus; C.S. Bale, sale, Christie's, 14 May 1881 (196), bt. McLean; W. Sturdy; sale, Christie's, 18 July 1922 (9), bt. Leggatt; A.T. Hollingsworth; E. Bulmer; Agnew, 1961; bt. Paul Mellon.
Coll.: Yale Center for British Art, Paul Mellon Collection, New Haven.
Lit.: Wilton 448; Shanes (II) 20.

This was one of the first watercolors that Turner made for later engraving in the "Southern Coast" series. Its smallness reflects

was fully alert to every detail in the scene. And almost at the tip of the long line of the bay which reaches out toward the left Turner places a cutter moving out to sea. (The transparency of its topsail suggests that the boat was an afterthought.) By converting the purely pictorial linear movement of the sweep of the shore into the implied slow movement of the cutter, Turner adds to the overall sense of lazy movement thoughout the drawing. This sensibility is furthered by the fact that there is virtually no wind: the cutter has all her (slack) sails raised, and on the right the pall of smoke rises haphazardly. Such details enhance even more the overall mood of peace and tranquillity.

29 WEYMOUTH, DORSETSHIRE, *c.* 1811. Yale Center for British Art, Paul Mellon Collection; New Haven, Connecticut.

the fact that to save having subsequently to scale up the engravings, the watercolors were made the same size as the print images from the outset. Such a requirement did not act as a limitation upon Turner, however. Instead, it seems to have spurred him into seeing how much information could be packed into such a relatively tiny area. Thus he gives us an extensive panorama looking around Weymouth Bay toward the Isle of Portland—in reality a peninsula—in the distance. Weymouth became fashionable for sea-bathing in the eighteenth century, and King George III frequented the town for that purpose, among others. Naturally, Turner therefore represents bathers on the beach in the foreground, along with fishing boats on the left, another economic mainstay of the place. Here, as elsewhere, a landscape is projected in more than simply its physical appearance. This was to be a characteristic of many of Turner's topographical watercolors made for engraving in series after 1811. However, that fact does not imply that the artist is not also wonderfully alert to the landscape itself. The long Georgian terraces fronting the bay, the gently incoming sea with its sparkling highlights, and above all the shafts of brilliant sunlight—effected by the careful placement of darker-toned washes over the existing drawing—indicate that Turner

30 HARDRAW FALL

Watercolor with scratching-out on white paper,
29.2 x 41.5 cm. *c. 1816.*
Eng.: by S. Middiman and J. Pye, 1818, for Whitaker's *History of Richmondshire* (R.182).
Prov.: William Quilter, sale, Christie's, 18 May 1889 (95), bt. Vokins; E. Steinkopf, sale, Christie's, 24 May 1935 (55), bt. Fine Art Society, London; Sir Jeremiah Coleman, sale, Christie's, 25 March 1955 (12), bt. Fine Art Society, London; J.E. Bullard, by whom bequeathed to the museum, 1961.
Coll.: Syndics of the Fitzwilliam Museum, Cambridge.
Lit.: Cormack 17, Wilton 574, Hill 3.

Hardrow Force in Yorkshire produces the highest unbroken fall of water in England, with a drop of some 96 feet. Predictably Turner makes it seem even higher by placing two tiny figures at its foot in the distance, mere dots in the landscape. Another recent visitor to the site is making his way back toward us along the path, while on a dry-stone wall sits a milkmaid who seems rather indifferent to the majestic scenery around her.

Turner visited the site sometime in July, 1816. David Hill even dates the visit to Sunday, 28 July 1816, which is merely inspired conjecture. The artist went to Hardrow Force in order to obtain material for the subsequent development of watercolors to be engraved as illustrations to the Rev. Thomas Dunham Whitaker's *History of Richmondshire*, a topographical and

50

antiquarian tome devoted to areas of north Yorkshire and Lancashire. This was to form part of a larger "History of Yorkshire" for which Turner was originally commissioned to make 120 drawings. In the end he only produced 20 since the literary side of the project was not a financial success. The pictures are entirely successful, however, as may be judged from both this work and the view of Hornby Castle also in this exhibition (#37). Turner's pencil drawings of the waterfall are on pages 15 and 28a of the *Yorkshire 5* sketchbook (T.B. CXLVIII). His observation of the structure of the limestone is commented upon in the main text, but it is also worth noting how the artist suggests that water falls from a great height in waves rather than just straight down. These surges also appear in most of the other pictures of waterfalls he created in his maturity. They are obviously his way of imparting the rapid movement of falling water.

31 TORBAY, SEEN FROM BRIXHAM, DEVONSHIRE

Watercolor on white paper, 15.8 x 24 cm. *c.* 1817.

Eng.: by W.B. Cooke, 1821, for the "Picturesque Views on the Southern Coast of England" series (R. 111).
Prov.: W.B. Cooke, bt. June 1817 for 10 guineas; Sir William Knighton, sale, Christie's, 23 May 1885 (410), bt. Vokins; Stephen G. Holland, sale, Christie's, 26 June 1908 (263), bt. Robson; Arthur Young, by whom bequeathed to the museum, 1936.
Coll.: Syndics of the Fitzwilliam Museum, Cambridge.
Lit.: Cormack 13, Wilton 486, Shanes (II) 34.

Brixham is an important fishing village situated on the southwest coast of England. Turner visited the place in 1811 to gather material for the "Southern Coast" series of watercolors and engravings, and he made an extremely rough sketch of this scene of page 48 of the *Corfe to Dartmouth* sketchbook (T.B. CXXIV). However, he greatly and very typically compresses the wide vista in the final image, for we look simultaneously northward along the coast and due eastward toward the rising sun. Yet despite the fact that he made only a slight study of the place he is as true to detail as ever, for the large vessel in the harbor with her sails raised is recognizably a Brixham

31 TORBAY, SEEN FROM BRIXHAM, DEVONSHIRE, *c.* 1817. The Fitzwilliam Museum, Cambridge.

"Mumble-Bee", a local ketch-rigged trawler. Many more of these boats are busily at work far out in Torbay in the pellucid morning air.

32 THE FIELD OF WATERLOO

Watercolor on paper, 28.8 x 40.5 cm. *c.* 1817.

Exh.: Grovesnor Place, 1819 (#34).
Prov.: Walter Fawkes; Major Richard Fawkes; A.W. Fawkes, by whom bequeathed to the museum, 1942.
Coll.: Syndics of the Fitzwilliam Museum, Cambridge.
Lit.: Cormack 14, Wilton 494.

In 1817 Turner made his second trip to the Continent, 15 years after his initial visit in 1802. This time he toured Holland, Belgium, and the Rhine, and quite naturally took the opportunity to visit the recent battlefield of Waterloo, just outside Brussels. He explored the site, probably on horseback, on Saturday, 16 August 1817 (according to notes in his sketchbook, T.B. CLIX) and later synthesized the present watercolor from sketches made on that day. Naturally, given his profound sense of history, the artist was thoroughly interested in the rela-

tionship of the battle to the lie of the land (perhaps, like Napoleon, being aware that "history is geography"). On sketches in the *Waterloo and Rhine* sketchbook (T.B. CLX) he noted such things as the number of casualties, the lines of advance and defense, and the spot where General Picton was killed. From these sketches he elaborated also a somber oil painting which he exhibited at the Royal Academy in 1818, representing the battlefield on the night after the battle. We can have no doubt that Turner was fully aware of the horrors of war since both that painting and this drawing make abundantly clear the identical price paid for victory and defeat in battle.

Across a foreground brutally strewn with both French and British corpses we look southward down the Nivelles road. The farmhouse of La Haye Sainte is at the center below the hill and Napoleon's headquarters, La Belle Alliance, can be seen on the horizon in the distance. The late afternoon of the actual day of battle, 18 June 1815, ended with sunlight amid cloudy but calm skies. By elaborating a furious thunderstorm in the distance Turner is therefore merely adding the natural effects most poetically and metaphorically appropriate to his subject, namely the "storm of war". The letters "N", for "Napoleon", and "GR", for "George Rex", may be noted in vertical juxtaposition on the right.

33 BRÜDERBURGEN ON THE RHINE

Watercolor and bodycolor on white paper
prepared with a gray wash, 21.2 x 32.7 cm. 1817.

Prov.: Walter Fawkes; by descent to the Rev. Ayscough Fawkes; sale, Christie's, 27 June 1890 (#16 as "Castles of the Two Brothers"), bt. Agnew; J.F. Schwann, sale, Christie's, 15 May 1925 (45), bt. Leggatt; the Hon. Mrs. Dighton-Pollock, by whom bequeathed to the museum, 1929.
Coll.: Syndics of the Fitzwilliam Museum, Cambridge.
Lit.: Cormack 15, Wilton 651.

Turner travelled down the Rhine between Cologne and Mainz in August and September, 1817, and elaborated a number of drawings of its scenery on specially prepared paper, probably shortly after his return to England when he went to stay in the

33 BRÜDERBURGEN ON THE RHINE, 1817. The Fitzwilliam Museum, Cambridge.

North Country (see also #34-36 following). Walter Fawkes purchased 51 of these drawings (including the present picture) for display at Farnley Hall, reputedly paying Turner 500 pounds for the set, a sum which tallies with the prices the artist was generally receiving for his watercolors at the time.

This work was synthesized from sketches on pages 58 and 93a of the *Waterloo and Rhine* sketchbook (T.B. CLX), and other studies of the same subject may also be found on pages 59, 60, 60a, 71a, and 72. The drawing represents the pair of ruins above Bornhofen on the east bank of the Rhine, the Sterrenberg and Liebenstein castles. According to legend the castles were built by two brothers (hence "brothers' castles") who had the misfortune to fall in love with the same maiden and who subsequently died at each other's hands while attempting to settle their dispute. (However, the real story is more prosaic: the castles were probably built by medieval robber barons.)

Turner clearly set himself a challenge by making all the drawings on paper which he had specially prepared in advance with a gray wash, and the ease with which he overcomes any difficulties of handling is a mark of his complete technical prowess. In particular, the great number of washed and scratched-out highlights give immense tonal and linear vivacity to the work.

34 BAUSENBERG (RHEINSTEIN CASTLE AND THE KLEMENSKAPELLE)

Watercolor and bodycolor with scraping-out on white paper prepared with a gray wash, 22.7 x 31.7 cm. 1817.

Prov.: Walter Fawkes; by descent to the Rev. Ayscough Fawkes, sale, Christie's, 27 June 1890 (5), bt. Agnew; Lloyd Roberts; Agnew, 1914; G. Newhouse; Viscountess Wakefield, by whom given in memory of her husband, Viscount Wakefield of Hythe, 1943.

Coll.: Victoria and Albert Museum, London (where it is catalogued as "A view on the Rhine").

Lit.: Wilton 640 and 683; Karl Heinz Stader, *William Turner und der Rhein*, Bonn, 1981, pp. 25-26 and color plate 37.

Until recently this drawing was known simply as "A view on the Rhine", but in 1981 Karl Heinz Stader identified the subject as a view of Rheinstein castle and the Klemenskapelle near the village of Trechtingshausen on the west bank of the Rhine about 20 miles north of Mainz. The castle was built in the twelfth century as a customs post by the Knights of Mainz and was known variously as Bausenberg, Bauzberg (under which name it appears on page 186 of Charles Campbell's book, *The Traveller's Complete Guide Through Belgium and Holland [and] Germany,* published in 1817, from which Turner obtained the name), Vautsberg, Voigtsberg, and Faitsberg. In 1825 Prince Frederick of Prussia had the castle rebuilt to plans by J.C. Lassaulx and renamed it "Rheinstein Castle". By identifying Turner's subject as Bausenberg on the Rhine, Stader was also able to demonstrate that this watercolor is the same work as a view of "Bausenberg" by Turner that was known to have been in the Fawkes collection. When that drawing subsequently passed through different hands its subject became misidentified as a view of Bausenberg near Niederzissen on the river Brohl, a tributary of the Rhine which enters its waters just above Andernach, some 60 miles north of the site actually depicted. Because of that subsequent misidentification, the real identity of the present work was lost—hence it was called "A view on the Rhine"—and it came to be thought that two pictures existed instead of one. Andrew Wilton thus gave the "missing" picture a number in his list of all of Turner's known watercolors. In fact, the drawings numbered 640 and 683 by Wilton are this same picture and share the same provenance.

The watercolor is based upon sketches on pages 65 and 67a of the *Waterloo and Rhine* sketchbook (T.B. CLX). On the left of the road which runs along the west bank of the Rhine, and nearly hidden by some trees, is the Klemenskapelle, a twelfth century late-Romanesque basilica. The moon rises over a distant bend in the river and before it rest some weary travellers.

34 BAUSENBERG (RHEINSTEIN CASTLE AND THE KLEMENSKAPELLE), 1817. Victoria and Albert Museum, London.

35 WEISSENTHURM AND THE HOCHE MONUMENT

Watercolor and bodycolor on white paper prepared with a gray wash, 19.7 x 31.1 cm. 1817.

Prov.: Walter Fawkes; bt. Agnew, 1912; Sir Algernon Firth; C.R.N. Routh; bt. Agnew, 1954; Mrs. Jane Taft Ingalls, by whom bequeathed to the museum, 1962.

Coll.: The Taft Museum, Cincinnati.

Lit.: Wilton 660.

Weissenthurm, or "white tower", is a village situated on the west bank of the Rhine about ten miles above Coblenz and opposite the town of Neuwied. The village takes its name from the square watch-tower depicted by Turner, which was erected to mark the boundary between the Electorates of Trier and Cologne. It was at Weissenthurm in 1797 that the French, led by their general Lazar Hoche, crossed the Rhine in the face of fierce opposition from the Austrians. (Julius Caesar similarly forced his way over the river at this point in pursuit of the Sicambri some 17 centuries earlier, in 55 B.C.) Hoche affected the crossing by throwing a bridge over to an island in the middle of the river. He died at Wetzlar shortly afterwards, apparently of natural causes. He was buried at Coblenz but in 1919 his remains were reinterred at Weissenthurm. A monument to his memory, in the form of an obelisk, was erected at Weissenthurm not long after his death and it appears on the extreme right of Turner's drawing. The view is to the southeast, although Turner has somewhat exaggerated the windings of the river, and the sun is therefore just rising.

36 FÜRSTENBERG

Watercolor and bodycolor on white paper
prepared with a gray wash, 23.5 x 31.1 cm. 1817.

Prov.: Walter Fawkes; by descent to the Rev. Ayscough
 Fawkes, sale, Christie's, 27 June 1890 (6), bt. McLean;
 anonymous sale, Christie's, 20 February 1904 (71),
 bt. McLean; James Blair, by whom bequeathed to the
 gallery, 1917.
Coll.: City Art Gallery, Manchester.
Lit.: Manchester 10, Wilton 641.

Fürstenberg Castle is situated on a height above the village of Rheindiebach, about three miles north of Rheinstein Castle (seen in #34). The castle dates from the thirteenth century and was destroyed by the French in 1689. In this watercolor, which was another of the 51 Rhine drawings bought by Walter Fawkes, Turner depicts the ruin as seen from the river. Obviously he was as much interested in the picturesque medieval walls and buildings fronting the Rhine as he was in Fürstenberg Castle itself. It may be noted that the artist repeats

36 FÜRSTENBERG, 1817. City Art Gallery, Manchester.

the square outline of the castle tower by the square sail far below it, and by the reflection of that sail upon the water. Through this repetition a subtle vertical emphasis ties the whole work together.

37 HORNBY CASTLE FROM TATHAM CHURCH

Watercolor on white paper, 29.2 x 41.9 cm. *c.* 1817.

Eng.: by W. Radcliffe, 1822, for Whitaker's *History of Rich-
 mondshire* (R. 185).
Prov.: John Sheepshanks, by whom given to the museum.
Coll.: Victoria and Albert Museum, London.
Lit.: Wilton 577, Hill 18.

Turner visited north Lancashire in August, 1816, as part of a tour to obtain material for the "History of Richmondshire" series (see #30). While there he made a number of studies of Hornby Castle, an imposing building whose keep dates from the early sixteenth century. This work is based directly upon an elaborate pencil outline on pages 41a-42 in the *Yorkshire 4*

37 HORNBY CASTLE FROM TATHAM CHURCH, *c.* 1817. Victoria and Albert Museum, London.

sketchbook (T.B. CXLVII) used on that tour. Tatham Church can be seen on the right with Hornby Castle catching the last rays of late afternoon sunlight in the center. Turner bathes the hillside on the right in golden sunlight and here, once again, his acute tonal mastery allows him to completely delineate form while virtually eradicating that form in light. In the foreground he provides considerable and charming anecdotal detail, including a child crying over spilt milk, a cat getting at the milk, and a milkmaid replenishing the supply. In the immediate foreground a cow rests its neck on a dry-stone wall. The curve of its neck is doubly amplified by the similar curves of a bough and branch of wood to its right—a typical play upon the similarity of forms by the artist.

38 THE WOODWALK, FARNLEY HALL

Watercolor and bodycolor on gray paper
heightened by white, 29.2 x 40 cm. *c.* 1818.

Prov.: Walter Fawkes; by descent to the Rev. Ayscough Fawkes; sale, Christie's, 28 June 1890 (43 as "In Wharfe-

dale with a rustic bridge"), bt. Woolner; Agnew, 1903; F. Stevenson, 1912; R. Norton, sale, Christie's, 26 May 1919 (130), bt. Sampson; Fine Art Society, 1930; Herbert Dean, sale, Sotheby, 19 November 1947 (132), bt. Agnew; Major Horton-Fawkes; Agnew; Gilbert Davies, sale, Sotheby, 19 March 1950 (105), bt. Messrs. John Mitchell, from whom purchased by the museum (Fairhaven Fund), 1958.
Coll.: Syndics of the Fitzwilliam Museum, Cambridge.
Lit.: Cormack 18; Wilton 602; David Hill, *Turner in Yorkshire*, York, 1980, pp. 44-45.

Turner probably made this watercolor in November, 1817, while staying at Farnley Hall as the guest of Walter Fawkes; as David Hill has pointed out, the autumnal coloring suggests that time of year. The picture probably represents a part of the estate known as The Glen which leads down to a small lake, known appropriately as Loch Tiny; this view looks up The Glen away from the lake. The work is based upon a pencil sketch on page 2 of the *Hastings* sketchbook (T.B. CXXXIX-2), although as usual Turner has invented much of the detail or at least recreated it from memory. For discussion of the fine linear values of the work, see the main text.

39 ST. MAWES, CORNWALL

Signed lower left: *JMW Turner.*
Watercolor and scraping-out
on white paper, 14.2 x 21.7 cm. *c.* 1822.

Eng.: by J.C. Allen for the "Picturesque Views on the Southern Coast of England" series (R. 116).
Prov.: W.B. Cooke, 1822; McCranker (McCracken), sale, Christie's, 31 March 1855 (83), bt. in; A.T. Hollingsworth, sale, Christie's, 11 March 1882 (75), bt. in; Francis Stevenson; James Orrock, sale, 4 June 1904 (43), bt. Edwards of Geneva; Agnew, from whom purchased by Paul Mellon, 1963.
Coll.: Yale Center for British Art, Paul Mellon Collection, New Haven.
Lit.: Wilton 473, Shanes (II) 39.

In 1811, in search of material for the "Southern Coast" series, Turner visited St. Mawes, a fishing village situated at the

mouth of the river Fal opposite Pendennis Castle which is seen in the distance. The tiny rough sketch of the place he made on that occasion (on page 133 of the *Devonshire Coast* sketchbook, T.B. CXXIII) served him well, for from it he also elaborated a complex oil painting of exactly this same scene which he exhibited at the Royal Academy in 1812, as well as a later watercolor made for the "England and Wales" series, a work last known to be in the United States but now lost. In all three of the pictures he fills the foreground with a scurry of activity as pilchard fish are sorted on the beach. In the center is the round tower of St. Mawes Castle, one of a chain of fortifications built by King Henry VIII to obviate the threat of French invasion.

The color of the drawing is very brilliant with sharp blues and reds countering the dominant yellows and whites. Turner here almost exclusively employs the three primary colors but without any feeling of restriction in the range of color. Both Pendennis Castle and the hillside on the right are typically raised to almost alpine heights.

40 FOLKESTONE, KENT

Watercolor on white paper, 15 x 24.2 cm. *c. 1822.*

Eng.: by R. Wallis for the "Picturesque Views on the Southern
 Coast of England" series, 1826.
Prov.: John Ruskin; by whom given to Sir John Simon;
 Humphrey Roberts; sold to Agnew, 1904; Scott and
 Fowles, New York; Charles P. Taft.
Coll.: The Taft Museum, Cincinnati.
Lit.: Wilton 480, Shanes (II) 44.

At the time Turner made this picture Folkestone was a small fishing village that was primarily dependent for its economic survival upon smuggling, a result of its close proximity to France. Indeed, at night the village would come alive with smugglers, and whole areas of the place were honeycombed with secret passages and hideouts for the dispersal of contraband. Turner revisited the village in 1821 and may even have gone out with the smugglers at night.

Here he represents the vista looking along the cliff-top known as the Lees, past the church of St. Mary and St. Eanswythe (known locally as "Hurricane House" because

of its exposed position) toward the harbor and cliffs stretching to Dover.

To understand fully what is depicted in the foreground, however, the work has to be related to three other watercolors by Turner. In the first picture, which was probably made in 1822 for engraving in the "Marine Views" series and which is still in the Turner Bequest (T.B. CCVIII-Y), the artist depicts the smugglers "sinking and creeping" kegs of gin (i.e. attaching the kegs to a rope which would be dropped to the shallow seabed and later "crept" or brought up while "fishing" during daylight hours.) In the second picture, which was made in 1824 for the "Marine Views" series and is now in a private collection, the kegs are seen being reclaimed at twilight. The present picture represents the kegs as having been carried inland and in the process of burial for later distribution elsewhere. In the final work, made around 1830 for the "England and Wales" series and now in the Yale Center for British Art, the smuggled goods are detected by customs men and confiscated.

It may be noted that one of the smugglers is lifting his hand to his brow. Perhaps he is wiping off sweat or alternatively hiding his face from us, an allusion to the desire to escape detection. Other features in these figures and the fine representation of the sea on the right are discussed in the main text.

41 THE DRACHENFELS

Pencil and watercolor with scraping-out
on white paper, 12.8 x 20.4 cm. *c. 1824.*

Eng.: by W. Finden for *Lord Byron's Works*, 1825 (R. 412); the
 plate was used again for Finden's *Landscape Illustra-*
 tions...of Lord Byron, 1833.
Prov.: (?) Thomas Brown, sale, Christie's, 8 June 1869 (650),
 bt. Vokins; Sir W. Cunliffe Brooks, sale, Phillips, 1901;
 Lady Cunliffe Brooks, sale, Phillips, 8 July 1903, bt.
 Agnew; James Blair, by whom bequeathed to the gallery,
 1917.
Coll.: City Art Gallery, Manchester.
Lit.: Manchester 12, Wilton 1216.

Byron was probably Turner's favorite contemporary poet: numerous quotations appended to the titles of pictures and a

number of subjects drawn directly from Byron attest to that fact. Moreover, the painter also created 26 highly detailed watercolors for engraving as illustrations to Byron's works. Seven of them were commissioned to adorn an edition of Byron which was intended for publication in 1825 but which failed to appear: this watercolor is one of those illustrations. The engraving finally appeared in 1833-34 along with the other 25 engraved designs.

The picture illustrates the long four-stanza poem on the Drachenfels interpolated between stanzas LV and LVI in the third canto of *Childe Harold's Pilgrimage*, of which this is a part:

> The castled crag of Drachenfels
> Frowns o'er the wide and winding Rhine,
> Whose breast of waters broadly swells
> Between the banks which bear the vine,
> And hills all rich with blossom'd trees,
> And fields which promise corn and wine,
> And scatter'd cities crowning these,
> Whose far white walls along them shine...

The Drachenfels is the 1,056-foot-high pinnacle of rock, surmounted by a tower, seen in the distance in the center. It is one of the Siebengebirge, or seven mountains, that dominate the Rhine near Bonn. Turner sketched the view on his Rhine tour in 1817. Up on the left is Rolandseck. According to legend this castle was named after Roland, a nephew of King Charlemagne, whose bride was immured in the Nonnenwerth convent on the island to the right. Roland was supposed to have built the castle in order that he might occasionally catch sight of her, and he lived the life of a lonely hermit while doing so. In reality, as with so many legends associated with Rhine castles, the building was erected by robbers whose depredations rendered them the terror of the vicinity. The scene is still recognizable today, although Turner has greatly and typically augmented the actual height of the hills on both sides of the Rhine and moved the convent, which is now a girl's school, far over to the right. The gorgeous coloring remains to its full extent, however, and demonstrates the powers of coloring Turner was capable of achieving by the early 1820s, a decade in which he was to move into a new dimension as a colorist.

42 DUNSTANBOROUGH CASTLE, NORTHUMBERLAND

Watercolor and bodycolor on paper, 29.1 x 41.9 cm. c. 1828.

Exh.: Moon, Boys and Graves Gallery, 1833 (#41).
Eng.: by R. Brandard for the "Picturesque Views in England and Wales" series, (R. 238).
Prov.: T. Tomkinson; (?) Thomas Burchall, 1857; H.A.J. Munro of Novar, sale, Christie's, 11 May 1867 (172), bt. John Heugh; sale, Christie's, 24 April 1874 (94), bt. Agnew; Sir William Armstrong; W.A. Watson-Armstrong, 1902; sale, Christie's, 24 June 1910 (38), bt. Agnew; James Blair, by whom bequeathed to the gallery, 1917.
Coll.: City Art Gallery, Manchester.
Lit.: Manchester 15, Shanes (I) 28, Wilton 814.

In 1825 Turner embarked upon the most ambitious project to issue engravings after his works with which he was ever to be associated, the "Picturesque Views in England and Wales" series. In all, 120 newly commissioned watercolors were to be engraved but by 1838, when only 96 prints had been issued, the project was terminated and the stock of engraved plates and prints auctioned off. Turner paid over 3,000 pounds to buy them all back. Nonetheless, the series did elicit some of his greatest watercolors, of which six are included in this exhibition.

Turner painted Dunstanborough Castle six times in all, producing three oil paintings, an additional watercolor, and a design in the *Liber Studiorum* series of mezzotint engravings. Quite evidently he was greatly drawn to the massive pile which stands in particularly splendid isolation on the northeast coast of England. The moral undertones of the present watercolor are discussed in the main text, but also worthy of note are other features: the freedom in the depiction of the sky, with color obviously floated onto the wet paper at the left; the economy of means by which Turner denotes the early morning shadows across the castle; the total grasp of movement in the waves; and the degree of observation that the artist brings to the reflections upon damp sand at the bottom left.

43 HOLY ISLAND, NORTHUMBERLAND

Watercolor with some bodycolor
and scraping-out, pen, and ink
on white paper, 29.2 x 43.2 cm. *c. 1828.*

Exh.: Egyptian Hall, Piccadilly, 1829 (#39); Moon, Boys and
 Graves Gallery, 1833 (#36).
Eng.: by W. Tombelson for the "Picturesque Views in England
 and Wales" series, 1830 (R. 243).
Prov.: G. Lowndes, 1833; B.G. Windus, 1835; D.R. Davies;
 anonymous sale, Christie's, 22 June 1917 (58), bt.
 Sampson; A.W. Nicholson; Viscountess Wakefield, by
 whom given to the museum, 1943.
Coll.: Victoria and Albert Museum, London.
Lit.: Shanes (I) 33, Wilton 819.

Holy Island is named after the monastery founded there by St.
Aidan in 635 A.D. It was destroyed by the Vikings in 793 and
sacked again by the Danes in the ninth century. The cathedral
that Turner represents was built by Benedictine monks from
Durham in the eleventh century but was destroyed during the
Reformation. In the distance on the right is Lindisfarne Castle
which dates from 1549. It was ruined during the Civil War, but
rebuilt by Sir Edwin Lutyens earlier this century and it is now
in use as a private residence.

Turner visited both Dunstanborough Castle (#42) and
Holy Island on his first tour of the north of England in 1791.
The drawing upon which he based the view of Dunstanborough
may be found on page 45 of the *North of England* sketchbook
(T.B. XXXIV) which was used on that tour. The present work
derives from a line drawing to be found a few leaves later, on
page 51 of the book. Nearly 31 years after first viewing the
spot, however, Turner supplied all the details of lighting and
staffage in both works from memory and imagination. One
detail in this picture was very up-to-date in the late 1820s when
the drawing was made: on the extreme right is a steamship.

The storm passes away to the south, leaving the cathedral
ruins gleaming in the sharp and doubtlessly cold, damp sun-
light. Relief supplies are being unloaded. The island is linked
to the mainland by a causeway at low tide; evidently the storm
has prevented its recent use. Especially worthy of note is the
bold and vibrant depiction of the sky, the waves rolling up the
beach, the rendering of wet sand, and the particularly fine
observation of both the forms of the rocks at the center and their
shadows.

44 MALVERN ABBEY AND GATE, WORCESTERSHIRE

Watercolor with some scraping-out
on paper, 29.9 x 42.8 cm. *c. 1830.*

Exh.: Moon, Boys and Graves Gallery, 1833 (#14).
Eng.: by J. Horsburgh for the "Picturesque Views in England
 and Wales" series, 1832 (R. 258).
Prov: B.G. Windus, 1833; John Heugh; Agnew, 1862; James
 Price; W. Quilter, sale, Christie's, 9 April 1875 (246), bt.
 Agnew; W. Thompson, 1877; Agnew, 1902; James Blair,
 by whom bequeathed to the gallery, 1917.
Coll: City Art Gallery, Manchester.
Lit.: Manchester 16, Shanes (I) 43, Wilton 834.

This drawing, made for the "England and Wales" series, is
Turner's second depiction of the same view of Malvern Abbey

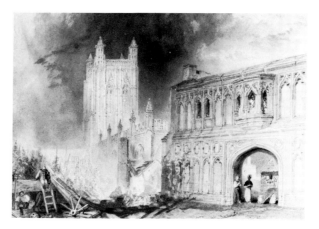

44 MALVERN ABBEY AND GATE, WORCESTERSHIRE,
c. 1830. City Art Gallery, Manchester.

and Gate. The first work, dating from 1794, is now in a private collection in the United States. The Benedictine priory was founded in the eleventh century but most of its architecture dates from the fifteenth century. The priory is today a parish church, and the gatehouse is a local history museum.

In both the 1794 and present drawings Turner introduces objects which he doubtless originally observed at Great Malvern. These objects include a frame saw, seen here on the left, and a broken wagon wheel. In addition, he litters the foreground with a wagon harness block, a wheel hub, and joinery tools. The carpenters have broken off their sawing, presumably because of the oncoming storm, and will doubtless take refuge with the youth and milkmaid on the right. The delineation of the architecture is quite superb, and no less noteworthy are the rendering of shadows across a corner of the gatehouse, the varied reflections across the surfaces and windows of that building, and the sense of movement in the sky. This latter effect is brought about by the multitude of stippled marks as much as by the rendition of forms. When the work was engraved Turner had a bolt of lightning added to the image, but the need for it would have been questionable here: the watercolor has a sufficiency of dramatic tension, not the least of which emerges from its extremes of hot and cold colors which were, of course, not available to the print.

45 JEDBURGH ABBEY

Watercolor on white paper, 9.4 x 15.9 cm. *c.* 1832.

Exh.: Moon, Boys and Graves Gallery, 1832, 1833.
Eng.: by R. Brandard, 1833, for Scott's *Poetical Works,* 1834 (R. 495).
Prov.: R. Cadell; Henry Cooke; Agnew, 1858; T. Rought; John Feetham, sale, Christie's, 27 May 1895 (III), bt. H. Quilter; Agnew, 1904; Scott and Fowles, New York; Charles P. Taft.
Coll.: The Taft Museum, Cincinnati.
Lit.: Wilton 1072.

In 1831 Robert Cadell, who was Sir Walter Scott's publisher, commissioned Turner to make a series of illustrations for a new edition of Scott's *Poetical Works.* As a result Turner visited Scotland, staying with Scott at Abbotsford, his palatial home near Melrose, and going on to tour the Highlands. In all, the painter made 24 drawings for the poetry edition and another 40 for an edition of Scott's *Prose Works,* which Cadell also subsequently produced. The poetry illustrations are in two forms: vignettes with cartouche surrounds (#46) and frontispieces, of which the present drawing is an example.

Jedburgh Abbey in Roxburghshire was founded by King David I of Scotland in 1147, and the church was built later in the century. Both were virtually destroyed in the early sixteenth century although a new church was constructed in 1875. Turner made sketches of the abbey on pages 62-65 of the *Abbotsford* sketchbook (T.B. CCLXVII). The engraving of this watercolor appeared as the frontispiece to Volume II of the *Poetical Works,* a volume which contains Scott's *Minstrelsy of the Scottish Border.*

The picture depicts the view looking northward down the river Jed in early evening light. Turner amplifies the rhythms of the arches of the abbey by means of the repeated curves of the washerwomen before it, and the outstretched arm of a man on the right similarly repeats and augments the formal projection of a flying buttress beyond him.

46 JOHNNY ARMSTRONG'S TOWER

Vignette watercolor on white paper, inscribed,
28.2 x 20.6 cm. *c.* 1832.

Exh.: Moon, Boys and Graves Gallery, 1832, 1833.
Eng.: by E. Goodall for Scott's *Poetical Works,* 1834 (R. 496).
Prov.: Robert Cadell; H.A.J. Munro of Novar, sale, Christie's, 2 June 1877 (2), bt. Gibbs; Lady Ashburton; Scott and Fowles, New York; Charles P. Taft.
Coll.: The Taft Museum, Cincinnati.
Lit.: Wilton 1073.

Turner drew this subject on page 61a of the *Minstrelsy of the Scottish Border* sketchbook (T.B. CCLXVI) and the design was engraved on the title page of Volume II of Scott's *Poetical Works* opposite the frontispiece of *Jedburgh Abbey* discussed immediately above (#45). The figures on either side were not included in the engravings printed in the octavo edition of Scott's poems.

Johnny Armstrong was the Laird of Gilnockie at the beginning of the sixteenth century and the most notorious Borders reiver, or raider, of his day. His clan could field some 3,000 armed men and they completely dominated the so-called "debatable land" between Langholm in Scotland and Longtown in Cumbria, England. Johnny Armstrong was hanged in 1529, along with 36 of his followers. His "tower" is today called either Hollows Tower or Gilnockie Tower and is situated just outside Langholm on the river Esk. It has subsequently been re-roofed and is now a private dwelling.

Turner injects a great deal of urgency into the scene, principally by means of the dynamic compositional arabesques running up through the design, and by the swirling forms in the sky. Their tempestuous rhythms also greatly enhance the sense of rushing that is implied by the stagecoach in the foreground. By contrast Johnny Armstrong's Tower looks very forlorn indeed.

47 THE DEATH OF LYCIDAS—"VISION OF THE GUARDED MOUNT"

Vignette watercolor on white paper, 19.9 x 14.8 cm. c. 1834.

Eng.: by W. Miller for Milton's *Poetical Works*, 1835 (R. 603).

Prov.: H.A.J. Munro of Novar, sale, Christie's, 2 June 1877 (31), bt. Bromley (Bromley-Davenport?); George Gurney, sale, Christie's, 17 March 1883 (198), bt. in; George Gurney, sale, Christie's, 11 July 1903 (42), bt. Agnew; Scott and Fowles, New York; Charles P. Taft.

Coll.: The Taft Museum, Cincinnati.

Lit.: Wilton 1269.

The engraving of this watercolor appeared as the title-page vignette to Volume VI of an edition of Milton's *Poetical Works,* published in 1835, which contained the poem *Lycidas.* The list of illustrations at the front of the book gives Turner's work the title of *The Death of Lycidas—"Vision of the guarded Mount".* This title is therefore the only correct one for the work and thus has been readopted here. (At present this watercolor is catalogued at the Taft Museum under the title of *Saint Michael's Mount.*)

Milton was moved to write *Lycidas* by the death of a friend at sea in 1637. The 1835 edition of Milton enjoys notes by both Allan Cunningham, a London journalist and art editor of the *Athenaeum* between 1834-40 (who was known to Turner), and Sir Egerton Brydges, Bart. Through Cunningham it seems likely that Turner discussed his illustrations with Brydges. In his notes at the end of *Lycidas* (p. 33), Brydges explains the line of verse which is attached to the title of Turner's picture in the list of illustrations and thus indirectly makes clear the connection between the death of Lycidas and St. Michael's Mount in Cornwall, which Turner depicts. Brydges explores the lines:

> Where the great vision of the guarded mount
> Looks towards Namancos and Bayona's hold;
> Look homeward, angel...
> (lines 161-163)

According to Brydges these verses denote the fact that the Angel, St. Michael, whom Milton "with much sublimity of imagination supposes to be still throned on [the] lofty crag of St. Michael's Mount in Cornwall, looking towards the Spanish coast" (i.e. toward "Namancos" and "Bayona") should "look no longer seaward to Namancos and Bayona's hold: rather turn your eyes to another object: look homeward or landward; look towards your own coast now, and view with pity the corpse of the shipwrecked Lycidas floating thither."

This is exactly what Turner represents: "the famous apparition of St. Michael" appearing above St. Michael's Mount in Cornwall, looking homeward toward the drowned Lycidas floating with rigid, outstretched arms far, far below.

48 POWIS CASTLE, MONTGOMERY

Pencil and watercolor on white paper,
28 x 48.9 cm. *c. 1834.*

Eng.: by J.T. Willmore for the "Picturesque Views in England and Wales" series, 1836 (R. 285).

Prov.: Birch; Agnew, 1854; sold to Joseph Gillot; his sale, Christie's, 4 May 1872 (507), bt. Agnew; J. Gillot, sale, Christie's, 30 April 1904 (23), bt. McLean; Humphrey Roberts; Agnew; from whom bt. by James Blair, 1906; his bequest to the gallery, 1917.

Coll.: City Art Gallery, Manchester.
Lit.: Shanes (I) 69, Wilton 861.

The topographical details of this watercolor derive from a pencil sketch of Powis Castle which appears on page 61 of the *Hereford Court* sketchbook (T.B. XXXVIII) used on Turner's tour of Wales in 1798. Some 36 years later Turner returned to the sketchbook and copied the layout of the landscape, adding a multitude of details from memory and imagination. For a discussion of the dramatic level of the work see the main text.

49 LYME REGIS

*Watercolor and bodycolor with scraping-out
on white paper, 29.2 x 44.8 cm.* *c.* 1835.

Eng.: by T. Jeavons for the "Picturesque Views in England and Wales" series, 1836 (R. 290).
Prov.: Isaac Cook; T. Rought; Agnew, 1859; J. Heugh, sale, Christie's, 28 April 1860 (207), bt. Gambart; W.W. Pattinson, sale, Christie's, 21 June 1875 (27), bt. in; John Wheeldon Barnes, sale, Christie's, 7 April 1894 (136), bt. Wigzell; Emilie L. Heine, by whom given to the museum in memory of Mr. and Mrs. John Hauck, 1940.
Coll.: Cincinnati Art Museum.
Lit.: Shanes (I) 74, Wilton 866.

Like the previous drawing this watercolor was made for engraving in the "Picturesque Views in England and Wales" series. It is based upon some very slight sketches which appear on pages 36, 39, and 41 of the *Devonshire Coast No. I* sketchbook, used on Turner's first tour of the southwestern coastline of England in 1811.

Lyme Regis, in Dorset, is a town whose principal recent claim to fame is that it is the setting of John Fowles' novel, *The French Lieutenant's Woman.* On the left of Turner's watercolor is the Cobb, an eighteenth century breakwater which is featured in the novel. Before the promontory we see a sailing vessel attempting to retrieve a ship's mast and top which are apparent above it. Turner here indulges one of his favorite habits in his marine pictures: afforded a wide arena for the dispersal of his shipping, instead he chooses to jumble it all together, obviously because he enjoyed the abstract patterns it makes as a result.

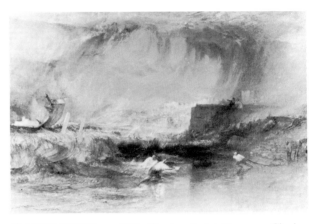

49 LYME REGIS, *c.* 1835. Cincinnati Art Museum, Cincinnati, Ohio.

This density of form is further enhanced by some stanchions which are being washed ashore by the breakers. On the beach some men heave more wreckage out of the sea and prepare to attach a line from a horse to pull it inland. Beyond another (fictional) breakwater Turner depicts Lyme Regis bathed in brilliant light. By means of a downward curving shoreline perhaps he alludes to the fact that the extremely low town regularly suffered flooding during spring tides, a danger that was referred to in the letterpress text which accompanied and explained the engraving. The breakers really force their way onto the beach where, once again, Turner fully conveys the texture of damp sand. The sky displays a violence of handling which we more usually associate with oil paint rather than watercolor.

50 OXFORD FROM NORTH HINKSEY

*Watercolor and bodycolor on white paper,
35.2 x 51.6 cm.* *c.* 1835-40.

Eng.: by E. Goodall, 1841 (R. 651).
Prov.: H.A.J. Munro of Novar, sale, Christie's, 6 April 1878 (81), bt. Agnew; J.S. Kennedy, sale, Christie's, 18 May

1895 (94), bt. Tooth; Wallis & Son, The French Gallery; James Blair, by whom bequeathed to the gallery, 1917.
Coll.: City Art Gallery, Manchester.
Lit.: Manchester 26; Rawlinson 651; Wilton 889; Shanes, "Picture Note," *Turner Studies*, Vol. I, No. 2, Winter 1981, p. 52.

As stated above, this drawing was subsequently engraved by Edward Goodall (R. 651) and the engraving published on 1 January 1841 by James Ryman, a printseller of High Street, Oxford.

Frederick Goodall (the son of the engraver) wrote of the genesis of the work in his *Reminiscences*, published in 1902:

My father was commissioned by a publisher to engrave a large drawing after Turner of "A distant View of the City of Oxford". One of the Dons of a College accompanied Turner to the spot from which they wanted the drawing made. The first day he [Turner] went up he said "This won't do; I must come up again"; but a second visit proved fruitless. When they got up to the hill on the third day, a thunderstorm was coming on, with dark purple clouds over the city, bringing out all the fine buildings into light against it. "This will do", said Turner, "I don't want to make a sketch; I shall remember this". And he certainly knew every building in Oxford, for he had drawn them when he was a boy. But when the plate was being engraved, the publisher asked my father to go down to the spot and look at the view. He took me with him, with my sketchbook to make the drawings of the distant buildings, and put them in their proper places, for Turner was a little careless about that. I went down and made the drawings to help my father in his engraving. But, I thought, when I looked at the city, that it was not as beautiful as Turner had made it. The effect was extremely fine with the dark purple clouds above. I had never seen the city of spires and towers under that aspect.

The drawing is based upon a synthesis of sketches in the *Moselle and Oxford* sketchbook (T.B. CCLXXXIX) of around 1834, most particularly pages 25-25a which contain a very detailed topographical study of the scene. There are also further studies on pages 17a-18, 21a, and 24. In addition, there are sketches of the view on the inside front cover of T.B. CCLXXVIII. Turner used these sketchbooks during his stay with James Ryman in July, 1834. W.G. Rawlinson suggests that the drawing was made during that visit, but he also states that the two Dons depicted on the right had followed Turner "...to watch him painting, and he put them in the picture". However, although at least one Don accompanied Turner on his first visit, the statement that Turner made the drawing on the spot is disproved by Goodall. Turner obviously introduced the Dons into the picture because they are a natural ancillary to such a scene.

Until 1934 this work was known in Manchester as "Oxford from Headington Hill". In that year Sir Kenneth Clark suggested that this title was misleading as the view of Oxford is from elsewhere. As a result it was thereafter known as "Oxford from Boar's Hill". However, neither of these titles is authentic, and the picture's proper title (taken from the engraving) is given above.

51 WINANDER-MERE, WESTMORELAND

Pencil, watercolor, and bodycolor
on white paper, 29 x 46 cm. *c.* 1835.
Eng.: by J.T. Willmore for the "Picturesque Views in England and Wales" series, 1837 (R. 298).
Prov.: George Pennell; sold to Agnew, 1859; repurchased by G. Pennell; J. Gillot, sale, Christie's, 4 May 1872 (508), bt. Lane; Earl Dudley, sale, Christie's, 11 June 1909 (184), bt. Agnew; James Blair, by whom bequeathed to the gallery, 1917.
Coll.: City Art Gallery, Manchester.
Lit.: Manchester 25, Shanes (I) 82, Wilton 874.

This lovely "England and Wales" series drawing depicts the view looking southward down Lake Windermere, the largest of the English lakes. Turner probably based the layout of the work upon pencil sketches made some 38 years earlier on his first tour of the Lake District in 1797. These appear on pages 52, 54, 55, and 56 of the *Tweed and Lakes* sketchbook (T.B. XXXV). The watercolor represents the vista which can be seen from a point just south of the town of Bowness on the eastern shore of

the lake. The stillness and infinite reflectivity of the surface of the lake amid brilliant afternoon sunlight are established with great subtlety, and the true heights of the hills as they appear in reality are greatly enhanced by Turner's poetic imagination, as usual.

52 LAKE NEMI

Vignette watercolor, pencil, and bodycolor
on white paper, 18.5 x 14.5 cm. *c.* 1835.

Eng.: by E. Goodall (R. 638), apparently for Dr. Broadley's
 Poems (to be privately printed c. 1844?); plate also used
 later for *Art and Song*, 1867.
Prov.: Edward Fordham; sale, Christie's 30 April 1904 (48), bt.
 McLean; Scott and Fowles, New York; Charles P. Taft.
Coll.: The Taft Museum, Cincinnati.

This watercolor is one of six designs for engravings which were probably commissioned to adorn a private publication, the *Poems* of a Dr. Broadley. However, the publication of the book did not take place and the plate was later reprinted after Turner's death.

Lake Nemi is situated about 14 miles south of Rome, and Turner first visited the spot in 1819 on his initial visit to Italy, as well as perhaps again in 1828 when he stayed in Rome for several months. He was evidently responsive to its deep, still waters, for in addition to portraying them here, around 1846 he created a large watercolor in which we look upwards from its shore (a work now in the British Museum, London). There, as in the present picture, he represents a tower upon a promontory in the distance on the left.

The incredible precision of touch that Turner was still capable of achieving around the age of 60 can be seen especially clearly in this exquisite and jewel-like drawing.

53 A SCENE IN THE VAL D'AOSTA

Pencil, pen, watercolor, and bodycolor
on white paper, 23.7 x 29.8 cm. *c.* 1836.

Prov.: W.G. Rawlinson by 1902; Agnew; R.A. Tatton, 1917;
T.A. Tatton, sale, Christie's, 14 December 1928 (27), bt. Lockett Thomson of Barbizon House; from whom purchased in 1932 for 200 pounds and given by the Friends of the Fitzwilliam Museum, 1932.
Coll.: Syndics of the Fitzwilliam Museum, Cambridge.
Lit. : Cormack 35, Wilton 1430.

This watercolor is one of a whole group of drawings depicting mountain scenery which have been connected with a trip Turner possibly made in 1836 through the Val d'Aosta in north-western Italy with his friend and patron, H.A.J. Munro of Novar. However, the precise location of the subject still awaits positive identification.

The drawing is one of Turner's most breathtaking creations, with the paint both dragged and overlapped in transparent washes, as well as scraped and scratched (denoting numerous waterfalls, among other things), to create a powerful sense of movement up and across the mountains and through the sky. The color range is extremely wide, with areas of green melting into pinks and purples, back to yellows, and then into varieties of blues and whites: a whole spectrum, indeed, but with no trace of muddiness, nor any incongruity. Turner's sense of the dynamic unity of earth, space, and the elements—as well as of the smallness of mankind in comparison with the immensity of nature—receives vivid utterance here.

54 THE WHALE ON SHORE

Watercolor on white paper, 10 x 14.3 cm. *c.* 1837.

Prov.: John Feetham, sale, Christie's, 27 May 1895 (112), bt H.
 Quilter; Scott and Fowles, New York, 1903; Charles P.
 Taft.
Coll.: The Taft Museum, Cincinnati.
Lit. : Wilton 1307 (as "The Great Whale")

Until now this drawing has proven a complete mystery: judging by its size and detail it was evidently made for engraving as a book illustration but the work for which it was destined was unknown. It has been suggested by Andrew Wilton that Turner made the watercolor around 1839 in response to a reading of Thomas Beale's *The Natural History of the Sperm Whale*, first published in 1835. Yet as Professor Robert K. Wallace of

Northern Kentucky University, Highland Heights, will be demonstrating in a forthcoming essay, such a response to that book could not have generated this watercolor, for Beale writes exclusively of the southern Sperm whale fishery, whereas in *The Whale on Shore* Turner depicts a Right or Greenland Whale which is hunted primarily in northern waters. Nor would Wilton's hypothesis explain why many of the figures in the drawing are evidently dressed in Scottish attire, a number of the men wearing kilts and the woman on the extreme right wearing plaid.

However, joint research by Professor Wallace and the present writer now establishes beyond any doubt that Turner originally made this watercolor for engraving in a book entitled *Landscape—Historical Illustrations of Scotland and the Waverley Novels* (of Sir Walter Scott) which appeared in two volumes in 1836 and 1837. This enjoys descriptions by the Rev. G.N. Wright and was published by Fisher and Son. (The book is usually known as Fisher's *Illustrations to the Waverley Novels*.) Seven engravings after designs by Turner appeared in this work, six of which were issued in the first volume in 1836 and one in the subsequent volume in the following year. Other artists who contributed illustrations to the book included Solomon Hart, J.D. Harding, Daniel Maclise, George Cruickshank (who contributed a number of comic designs), and Harden Sidney Melville whose dates are unknown but who was active between 1837 and 1881.

One of Melville's illustrations which appears on page 38 in Volume II of the work is entitled *The Whale on Shore* and pictorializes a passage from Scott's novel *The Pirate* which was first published in 1822. It is this selfsame passage that Turner clearly treats in the present watercolor. It seems certain, therefore, that Turner originally made his design to illustrate this passage (which is why the title of the work has been changed from *The Great Whale* to a more authentic form here) but for unknown reasons Melville's engraving was substituted for it. Both Turner's drawing and Melville's engraving are very similar in size and identical in format.

Scott's *The Pirate* is set in the northernmost of the British Isles, the Orkney and the Shetland Islands, to the northeast of Scotland. It tells of a Captain Gow who engaged in piracy during the early eighteenth century. The passage from *The Pirate* quoted on pages 39-41 of Volume II of Fisher's *Illustra-*

tions to the Waverley Novels tells of how a whale was washed ashore at Burgh Westra on Orkney, "A tide of unusual height [having] carried the animal over a bar of sand into the creek in which he is now lying." This sandbar is clearly visible in the middle-distance of Turner's watercolor, with only a shallow stream of water running across it and waves breaking beyond it. Finding the whale helpless, the islanders of "all parties, sexes, and ages united against the common and noble enemy, resolving to make a simultaneous attack, under the direction of the stout-hearted and experienced Udaller" (a tenant of land by udal right, an old native form of freeholding in the Orkneys and Shetlands) who is clearly the man directing operations in the center-foreground. Some of the clothing which Scott describes as being worn by the Udaller is depicted by Turner, including a bearskin cap and sea boots.

At first the whale was quiescent and "a council of experienced harpooners agreed that an effort should be made to noose the tail of the torpid leviathan, by casting a cable round it, to be made fast by anchors to the shore". One of these anchors can be clearly seen on the left, as can the end of one of the cables which was carried ashore and secured by the islanders. Having succeeded in this task, spears, harpoons, and guns were then respectively thrown and fired at the whale. Two of these guns can be seen going off on the right. Eventually the leviathan

...collected his whole remaining force for an effort [to escape], which proved at once desperate and successful. He roared aloud as he sent to the sky a mingled sheet of brine and blood [which may be seen emanating from the head of the whale in Turner's drawing], and snapping the strong cable like a twig, overset Mertoun's boat with a blow of his tail [the overturning boat is also visible midway along the whale, as is the gigantic splash made by this blow].

Predictably, Turner's design is far more inventive than Melville's, which barely shows the whale and includes some extremely wooden figures. Moreover, Turner gives us a far more dramatic sense of movement, with dynamic lines running along the crowds of figures pulling on the ropes attached to the whale, along the shapes of the coast slanting upwards to the right, and of course through the whale itself. Moreover, by means of their shape the cliffs immediately above the whale greatly amplify its discharge of brine and blood, while the artist virtually repeats the shape of the tail of the whale by that of an

anchor on the left. Only the shape of the triangular pointed fluke of the anchor reverses the triangle formed by the tail of the great mammal. An anchor also appears at the bottom left of Melville's image but doubtless the similar placing is entirely coincidental. One would give much to know why Turner's masterly design was rejected.

55 HEIDELBERG: SUNSET

Watercolor and scraping-out
on white paper, 38 x 55.2 cm. c. 1841.

Prov.: Vokins; Agnew, 1860; George Pennell; Agnew, 1860; John Heugh; Agnew, 1861; James Price; Agnew, 1873; William Quilter, sale, Christie's, 18 May 1889 (101), bt. Agnew; Mrs. Ruston, sale, Christie's, 4 July 1913 (104), bt. Agnew; Baron Goldschmidt-Rothschild; Agnew, 1914; James Blair, by whom bequeathed to the gallery, 1917.
Coll.: City Art Gallery, Manchester.
Lit.: Manchester 27, Wilton 1376.

Turner probably based the design and topographical details of this watercolor upon sketches found on pages 39 and 42 of the *Berne, Heidelberg and Rhine* sketchbook (T.B. CCCXXVI) as well as perhaps sketches found on pages 14, 15a, and 16 of the *Heidelberg up to Salzburg* sketchbook (T.B. CCXCVIII). There also exists what seems to be a preparatory study for the picture in pencil and watercolor (T.B. CCCLXV-34), a work inscribed "10 Mar 41" which might therefore be the date after which this watercolor was made. Sometime during the same period Turner also created an elaborate oil painting of *Heidelberg* (B.J. 440, London, Turner Bequest), a work which he never exhibited. As in this watercolor there appear in the painting a large number of figures who are dressed in historical costume. Indeed, when the painting was engraved after Turner's death the image was given the title "Heidelberg Castle in the Olden Time", a name which equally reflects the fact that Turner represents the castle as it appeared prior to its partial destruction by the French in 1689.

Clearly Heidelberg enjoyed especially strong historical associations for Turner. As a result the emotional impact of the present watercolor is greatly heightened, for the sense of the

passing of a glorious age is furthered by the historical costumes seen amid the last blaze of daylight and with the coming of night as represented by the rising moon.

56 BACHARACH

Pencil and watercolor on white paper,
18.4 x 24.1 cm. c. 1835-44.

(On the reverse is another study of Rhine scenery in pencil, watercolor, and scraping-out on paper prepared with a gray wash.)

Prov.: John Ruskin; Mr. Forster, by whom bequeathed to the museum.
Coll.: Victoria and Albert Museum, London.
Lit.: Wilton 1328 (as "On the Rhine"); Agnes von der Borch, *J.M. William Turner, Köln und der Rhein*, catalogue, Cologne, 1980, p. 105.

Although catalogued by both the Victoria and Albert Museum and Andrew Wilton under the title of "On the Rhine", Agnes

56 BACHARACH, *c.* 1835-44. Victoria and Albert Museum, London.

von der Borch has identified the subject as a view of Bacharach, a small town on the west bank of the Rhine about seven miles north of Rheinstein Castle and Trechtingshausen (see #34) and 35 miles south of Coblenz.

It is impossible to date the work exactly for it demonstrates a visual approach that can be encountered any time after about 1830. Unfortunately we also lack sure knowledge of Turner's movements along the Rhine in these years, so we can ascertain little as to its precise dating from that source either. Nonetheless it is a very lyrical work which demonstrates that the soft light, medieval buildings, and rolling hillsides of the Rhineland continued to exercise their charms upon Turner way into late middle age.

57 LAKE OF THUN

Watercolor on white paper, 36.9 x 54.1 cm. *c. 1845.*

Prov.: Gen. Rawdon; William Quilter, sale, Christie's, 9 April 1875 (237), bt. in; sale, Christie's, 18 May 1889 (97), bt. Agnew; Joseph Ruston, sale, Christie's, 4 July 1913 (106), bt. Agnew; Scott and Fowles; Charles P. Taft.
Coll.: The Taft Museum, Cincinnati.
Lit.: Wilton 1567.

This watercolor is dated to around 1850-51 by Andrew Wilton, who also suggests it may have been one of a final set of Swiss watercolors which Turner was perhaps still attempting to complete when he died. However, there is strong evidence to suggest that Turner had virtually been forced to give up watercolor painting by old age around 1848, so Wilton's dating may be too late for this drawing. Certainly the work shares characteristics with other pictures of Lake Thun which probably date from around 1844-45, the most notable feature of which is Turner's apparently artificial provision of a dais or platform in the foreground, as Wilton notes. Yet it is what Turner places upon the dais in this picture which suggests that the drawing was not necessarily one of the final set of Swiss watercolors that Wilton postulates, for nowhere in the other works which belong to the group does one encounter the kind of figures seen here. For example, on the left is a woman whose hair is worn in a seventeenth century style and who is wearing a large ruff and elegant gown. Clearly this figure, who could even be a sculpture, suggests that the picture may have been intended as an historical work. Similarly, the carriage passing on the left and the mother and child beneath the dominant tree suggest that there may have been some narrative or associative purpose to the work. It may, indeed, have been intended to display the kinds of historical associations of place which we can witness in *Heidelberg: Sunset* of around 1841 (#55).

There are also difficulties concerning the landscape represented, for there is nothing in the watercolor to identify the picture as a view of Lake Thun. It could even be an Italian scene, perhaps a panorama of the Arno valley near Florence: clearly we are looking along a river on the right rather than across a large body of water. And certainly the buildings and stone pine trees down on the right are much more Italianate than Swiss. Moreover, the work even shows a marked pictorial affinity with a drawing that is thought to be a view of Florence and identified as such by Wilton in his list of all of Turner's known watercolors (Wilton 1568; private collection, U.S.A.).

The picture therefore presents a number of problems. Unless some further evidence emerges, its precise date and subject must remain a mystery, even though a certain lack of cohesion in the drawing does support Wilton's contention that it is a very late work, produced when Turner's powers were on the wane. However, the brilliantly high-keyed and predominantly yellow coloring does convey the intensity of the light, and the sense of space is as powerful and convincing as ever.

58 SION, NEAR THE SIMPLON PASS

Pencil, pen, and watercolor on paper,
22.9 x 29.2 cm. *c. 1843.*

Prov.: probably the watercolor in the John Pound sale, Christie's, 25 March 1865, bt. Agnew (as "A view in the Tyrol—'Going to Market'," 11½ x 9½ in.); sold by Agnew to John Fleming; sale, Christie's, 22 March 1879 (57), bt. Agnew; Victoria and Albert Museum collection, 1879.
Coll.: Victoria and Albert Museum, London.
Lit.: Wilton 1494 as "An Italian town (in the Alps)".

This drawing bears a marked resemblance to the succeeding work in this catalogue and obviously represents the same subject.

Sion, the principal town of the Valais in southern Switzerland, is situated alongside the river Rhone and stands in a valley which links the St. Bernard and Simplon passes through the Alps into Italy. The road was almost destroyed by storms in 1834 and 1839 and was barely passable in 1840. Murray's *Handbook to Switzerland* of 1842 tells us that the Rhone valley around Sion was "a flat swamp, rendered desolate and unwholesome by the overflowing of the Rhone and its tributaries, which, not being carried off by a sufficient declivity in their beds, stagnate, and exhale a most injurious malaria under the rays of a burning sun. From this cause, and the absence of pure drinking water, the valley is a hot bed of disease; its inhabitants are dreadfully afflicted with goitre…cretinism and agues; and the appearance of decrepitude, deformity and misery arrests the traveller's attention at every step".

Turner toured Switzerland in the summers of 1841-44 and this work could date from either then or slightly later. The sense of damp atmosphere is most immediately conveyed by the reflections on the road at the bottom, but it exists throughout the work. It is enhanced rather than diminished by the lines drawn in ink, for the watercolor washes are thereby freed from playing a wholly denotive role and are allowed to flow through things, although not to the extent that they do in the following work. The figures, who are clearly on their way to market, may have been intended to convey something of the sad physical state of the inhabitants of Sion and its surroundings.

59 SION, NEAR THE SIMPLON PASS

Pencil and watercolor on white paper,
37.4 x 55.3 cm. *c.* 1845.

Prov.: L.B. Mozley, sale, Christie's, 27 May 1865 (184), bt. Agnew; John Fowler; E.F. White; Agnew, 1887; Lloyd Roberts, 1890; Dr. D. Lloyd Roberts, by whom bequeathed to the gallery, 1920.
Coll.: City Art Gallery, Manchester.

Lit.: Manchester 34, Wilton 1553.

In 1842 Turner made a set of ten elaborate watercolors of Swiss scenes for sale through his agent. Another set of six such drawings followed in 1843, while in 1845 the artist worked up a further set of ten Swiss scenes. In addition, Andrew Wilton argues (not altogether convincingly) that a fourth set evolved between 1846-51, a group to which both the *Lake Brienz* discussed immediately below (#60) and this work belong. Certainly both drawings share one immediately apparent characteristic, namely a sense of the dissolution of form into a constant flux of matter. The artist denotes some of the forms here mainly by touches of red or even lines drawn in red. But almost everywhere else there is a constant ebb and flow, with a few of the buildings, some sheep, and the distant mountains gleaming brilliantly and serving to heighten the overall visual intensity. Only the dark blue sky and mountain shadows which butt up against the church or the line of the hillside to its right, as well as the cliff below the church, refuse to share in this general breakdown of form: everywhere else the barriers between material objects disappear entirely. All is interactive, dynamic, flowing. The unity of earth and sky is complete and seems bound by the energy which underlies them.

60 LAKE BRIENZ

Watercolor, pen, and red ink
with scratching-out on white paper,
33.7 x 54.5 cm. *c.* 1846.

Prov.: Henry Vaughan, by whom bequeathed to the museum, 1900.
Coll.: Victoria and Albert Museum, London.
Lit.: Wilton 1562.

Although this lovely drawing is titled *Lake Brienz* there are in fact no features present in the watercolor which would serve positively to identify the subject as being a view of that lake. For example, there is in reality no promontory with two round towers projecting into Lake Brienz such as appears on the left of Turner's drawing. Moreover, the white building on the right bank of the lake is similar to William Tell's chapel which stands near Fleulen at the lower end of Lake Lucerne, but here

the surrounding lie of the land does not match that of Lucerne in any other respects.

Clearly we may just be looking at a landscape created from reminiscences of Swiss scenery, an imaginative synthesis of the type that Turner had frequently created of Italian views slightly earlier in his career. But whether or not Turner represents the real Lake Brienz in this watercolor, he certainly does present us with a scene which seems profoundly real in its own right because it represents the distillation of a lifetime's experience of mountain scenery. And in this most ideal of ideal landscapes, we see once again the endless flow of energy. Given the artist's known metaphysical affinities, such a dynamic of movement seems to express something beyond the corporeal world and possibly a divine constant underlying external nature. To this end the quite gorgeous coloring, which runs from the most intense golds to the deepest pinks, purples, greens, and blues, adds its own unearthly effect and conveys the most intense emotional power.

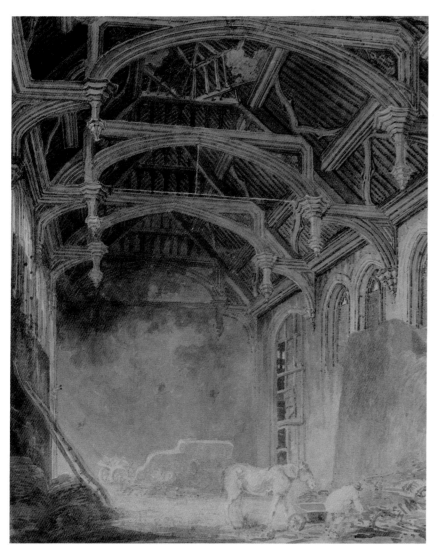

1 INTERIOR OF KING JOHN'S PALACE, ELTHAM, *c.* 1793.
Yale Center for British Art, Paul Mellon Collection; New Haven, Connecticut.

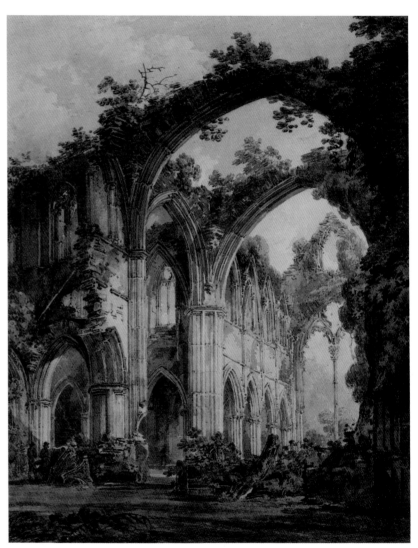

3 INSIDE OF TINTERN ABBEY, MONMOUTHSHIRE, 1794.
Victoria and Albert Museum, London.

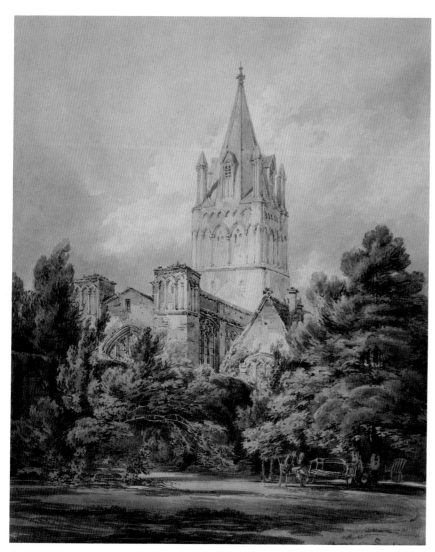

4 CHRIST CHURCH, OXFORD, 1794. The Fitzwilliam Museum, Cambridge.

8 ROCHESTER, KENT, 1795. City Art Gallery, Manchester.

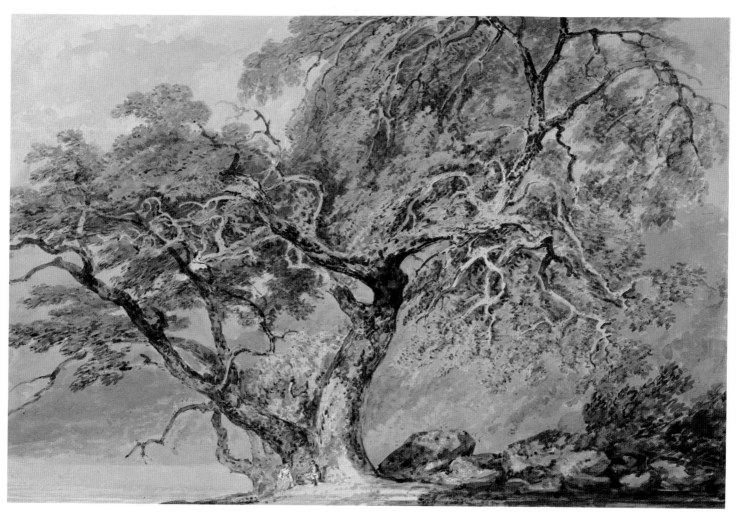

14 A GREAT TREE, *c*. 1796. Yale Center for British Art, Paul Mellon Collection; New Haven, Connecticut.

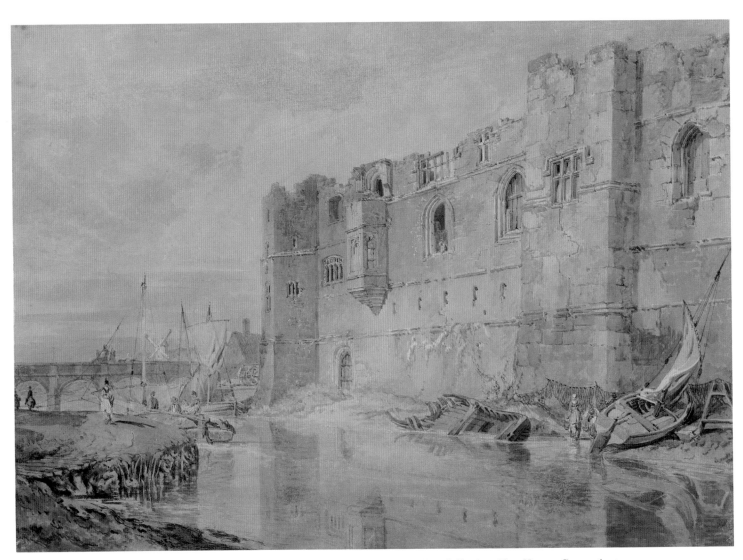

15 NEWARK-UPON-TRENT CASTLE, *c.* 1796. Yale Center for British Art, Paul Mellon Collection; New Haven, Connecticut.

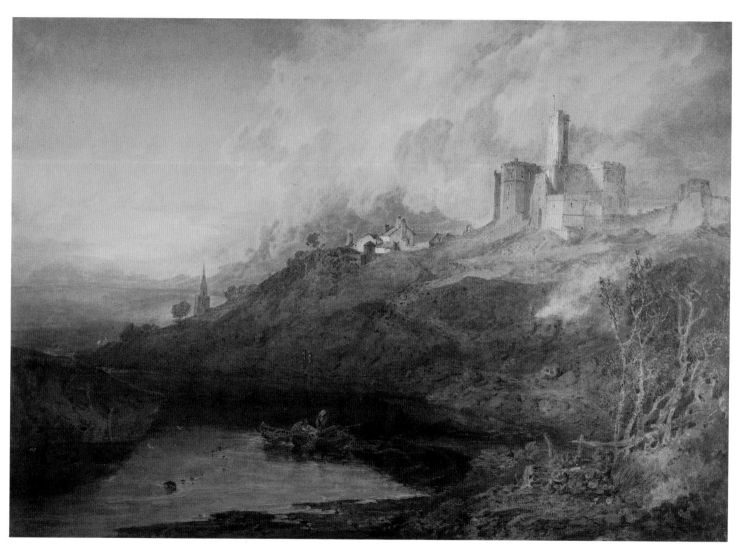

19 WARKWORTH CASTLE, NORTHUMBERLAND—THUNDER STORM APPROACHING AT SUN-SET, 1799.
Victoria and Albert Museum, London.

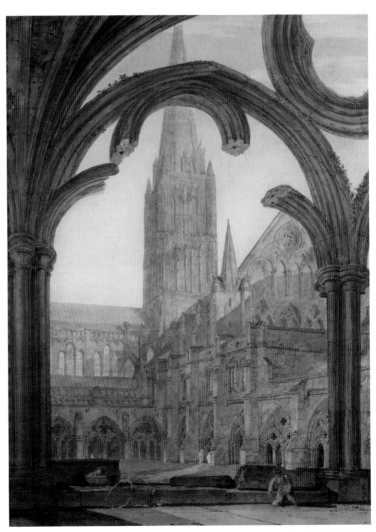

21 SOUTH VIEW FROM THE CLOISTERS, SALISBURY CATHEDRAL, *c*. 1802. Victoria and Albert Museum, London.

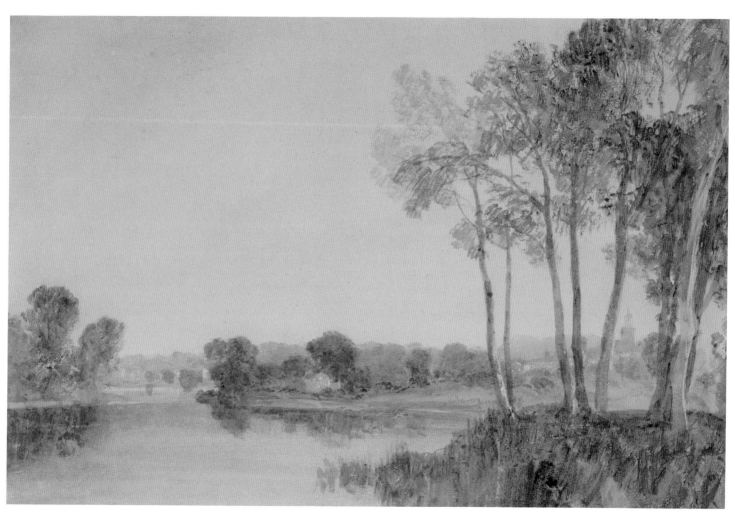

24 LANDSCAPE WITH TREES BY A RIVER, *c.* 1806. City Art Gallery, Manchester.

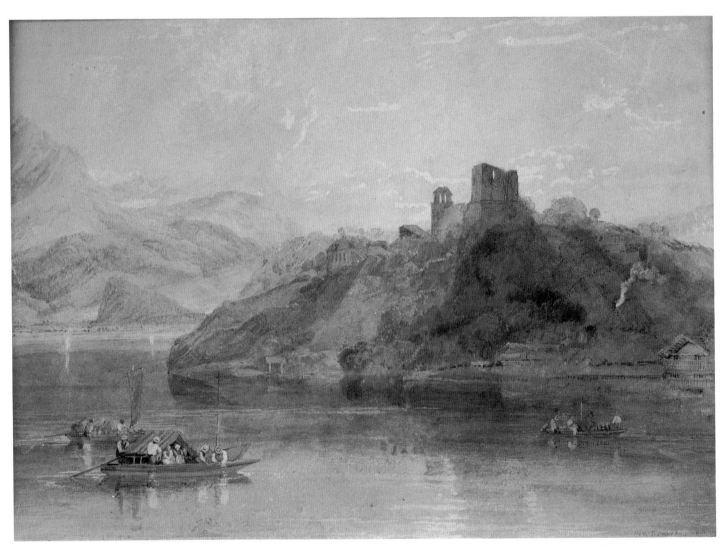

27 CHATEAU DE RINKENBERG, ON THE LAC DE BRIENTZ, SWITZERLAND, 1809. The Taft Museum, Cincinnati, Ohio.

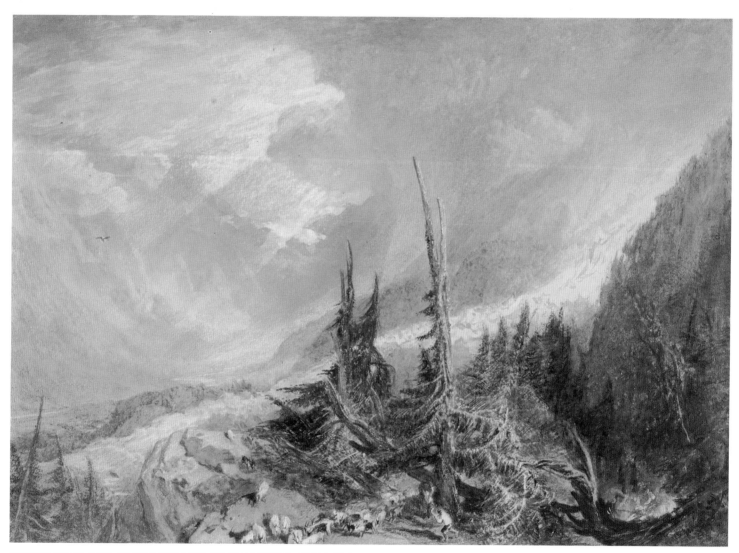

28 MER DE GLACE, IN THE VALLEY OF CHAMOUNI, SWITZERLAND, *c.* 1809. The Taft Museum, Cincinnati, Ohio.

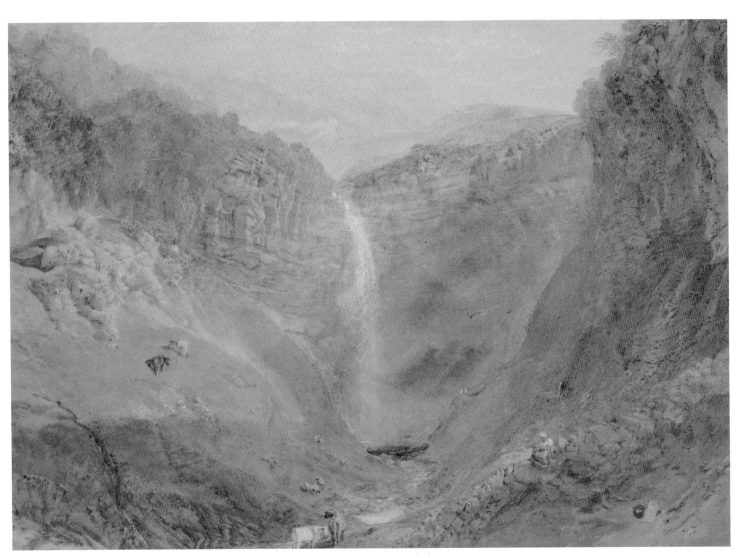

30 HARDRAW FALL, *c.* 1816. The Fitzwilliam Museum, Cambridge.

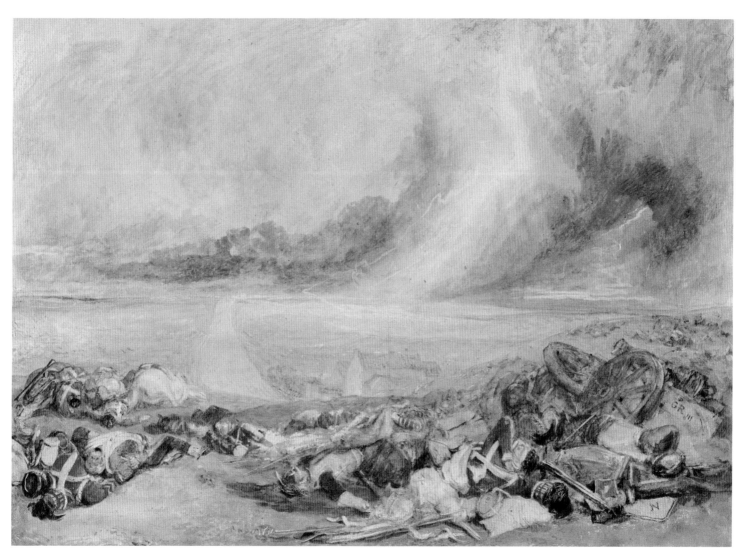

32 THE FIELD OF WATERLOO, *c*. 1817. The Fitzwilliam Museum, Cambridge.

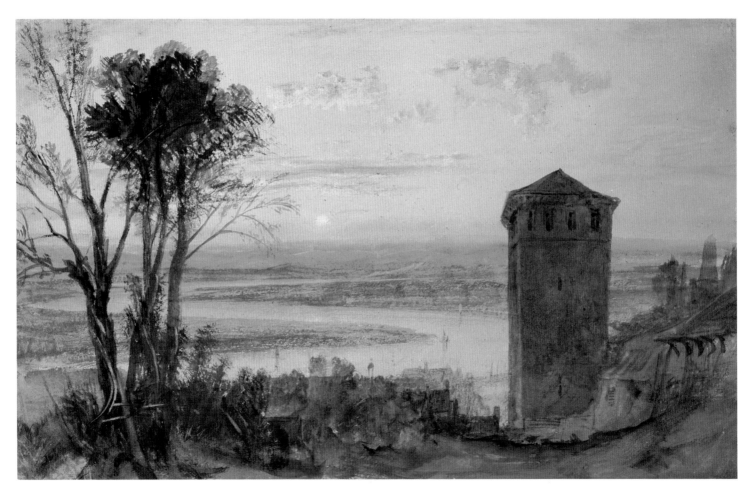

35 WEISSENTHURM AND THE HOCHE MONUMENT, 1817. The Taft Museum, Cincinnati, Ohio.

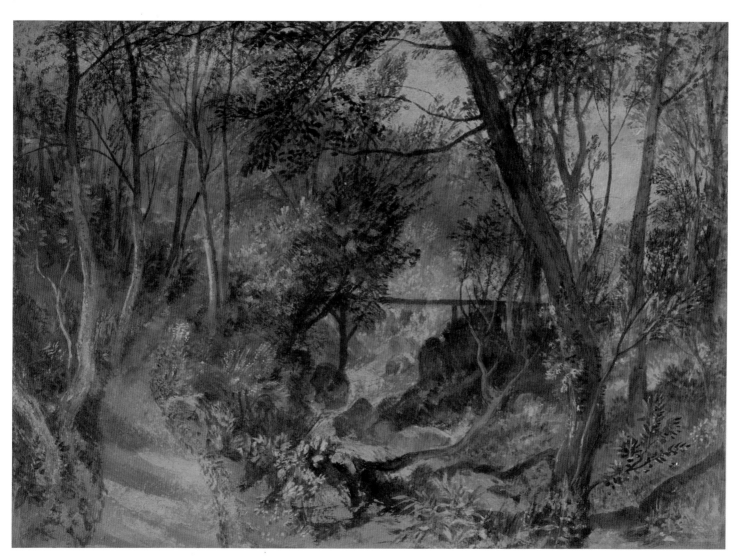

38 THE WOODWALK, FARNLEY HALL, *c.* 1818. The Fitzwilliam Museum, Cambridge.

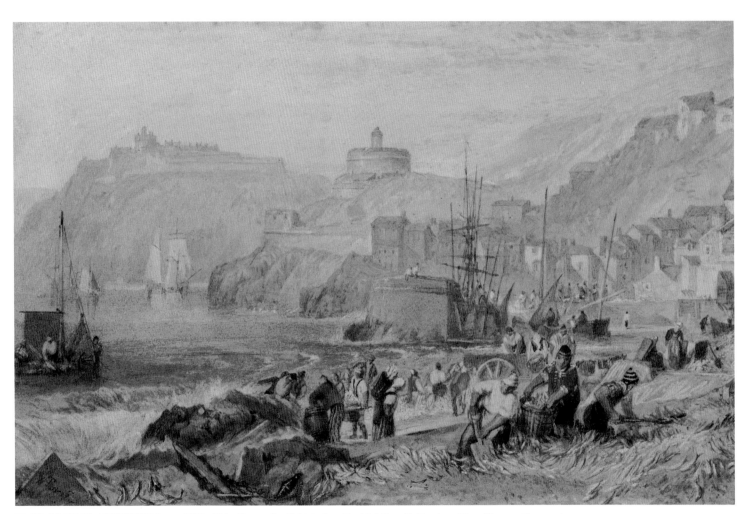

39 ST. MAWES, CORNWALL, *c.* 1822. Yale Center for British Art, Paul Mellon Collection; New Haven, Connecticut.

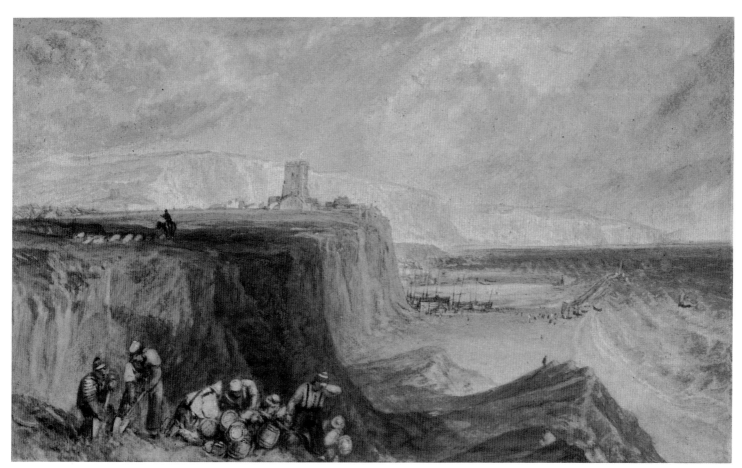

40 FOLKESTONE, KENT, *c.* 1822. The Taft Museum, Cincinnati, Ohio.

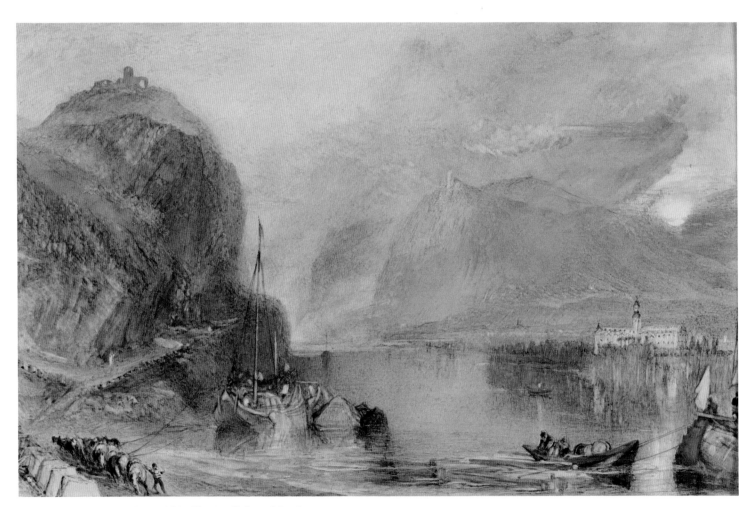

41 THE DRACHENFELS, *c*. 1824. City Art Gallery, Manchester.

42 DUNSTANBOROUGH CASTLE, NORTHUMBERLAND, *c.* 1828. City Art Gallery, Manchester.

43 HOLY ISLAND, NORTHUMBERLAND, *c.* 1828. Victoria and Albert Museum, London.

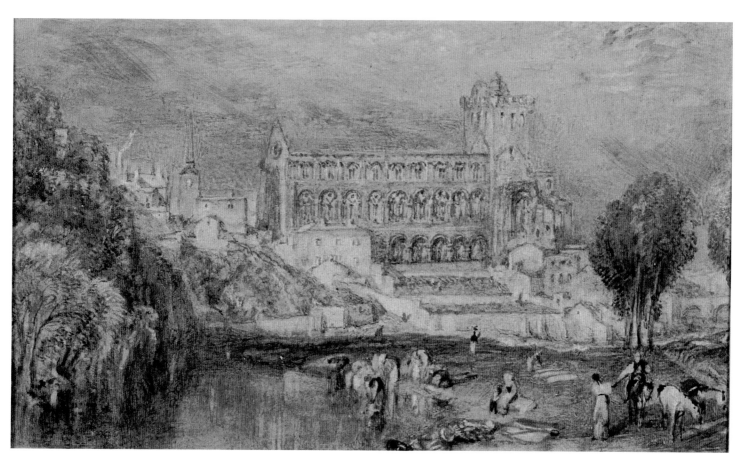

45 JEDBURGH ABBEY, *c*. 1832. The Taft Museum, Cincinnati, Ohio.

46 JOHNNY ARMSTRONG'S TOWER, *c.* 1832. The Taft Museum, Cincinnati, Ohio.

47 THE DEATH OF LYCIDAS—'VISION OF THE GUARDED MOUNT', *c.* 1834.
The Taft Museum, Cincinnati, Ohio.

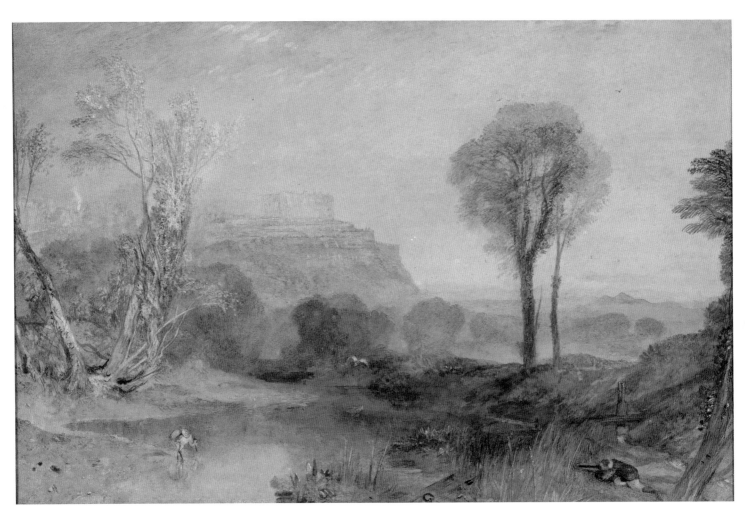

48 POWIS CASTLE, MONTGOMERY, *c.* 1834. City Art Gallery, Manchester.

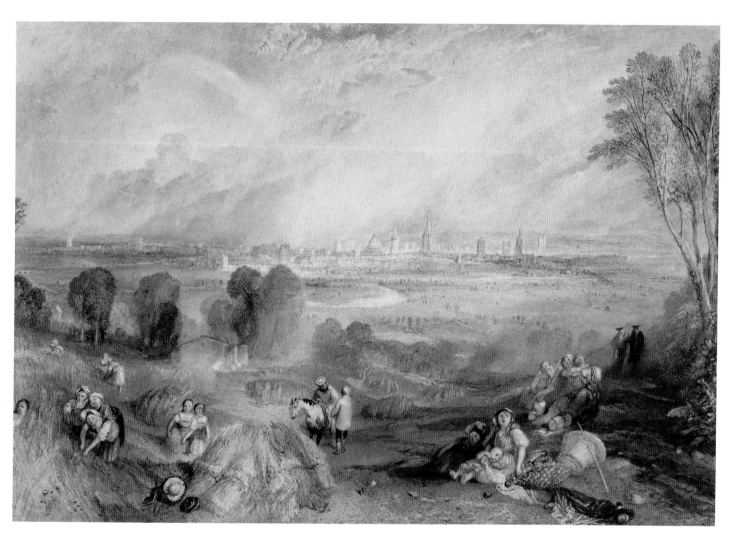

50 OXFORD FROM NORTH HINKSEY, *c.* 1835-40. City Art Gallery, Manchester.

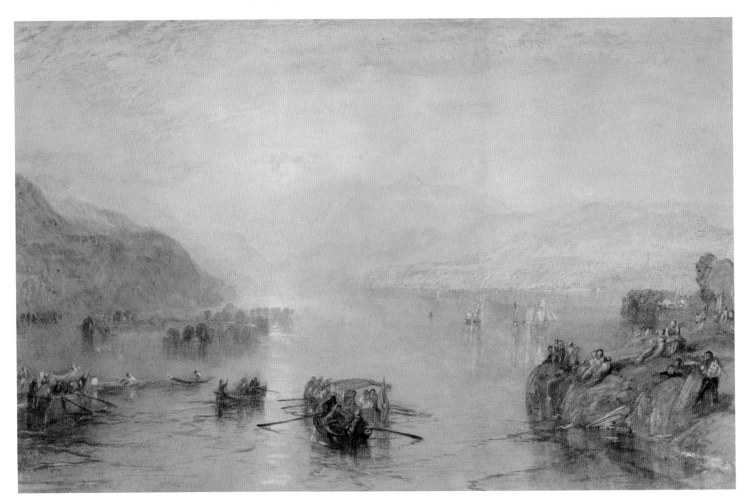

51 WINANDER-MERE, WESTMORELAND, *c.* 1835. City Art Gallery, Manchester.

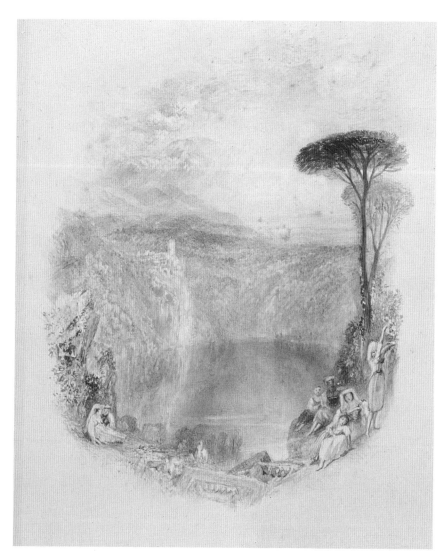

52 LAKE NEMI, *c*. 1835. The Taft Museum, Cincinnati, Ohio.

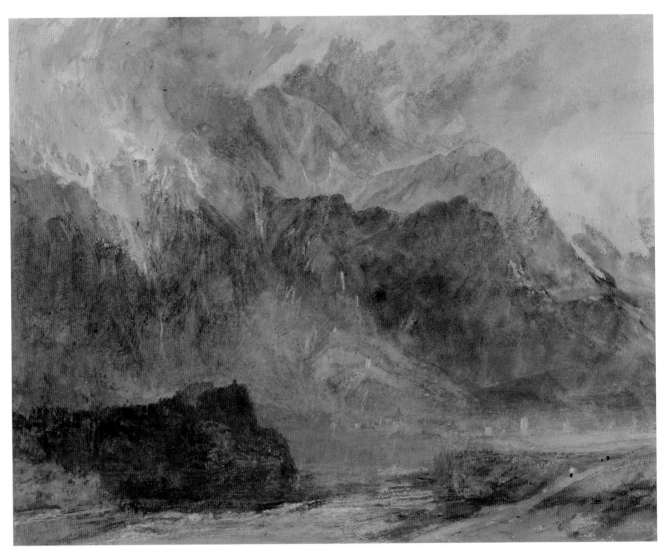

53 A SCENE IN THE VAL D'AOSTA, *c.* 1836. The Fitzwilliam Museum, Cambridge.

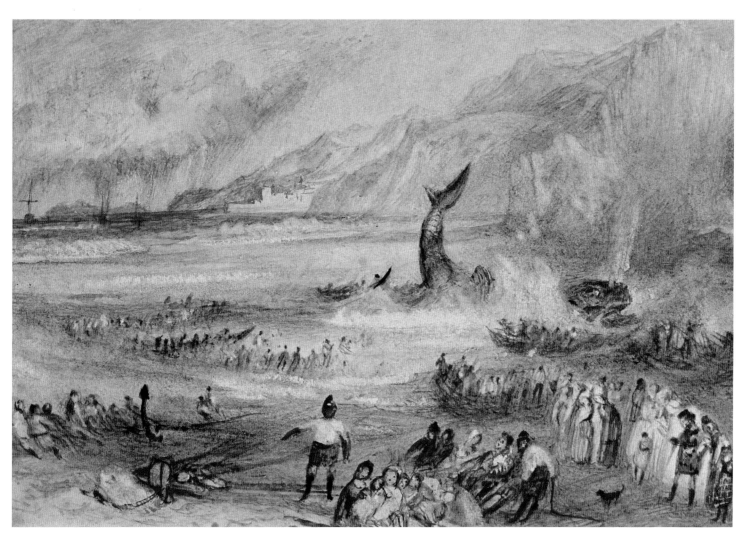

54 THE WHALE ON SHORE, *c*. 1837. The Taft Museum, Cincinnati, Ohio.

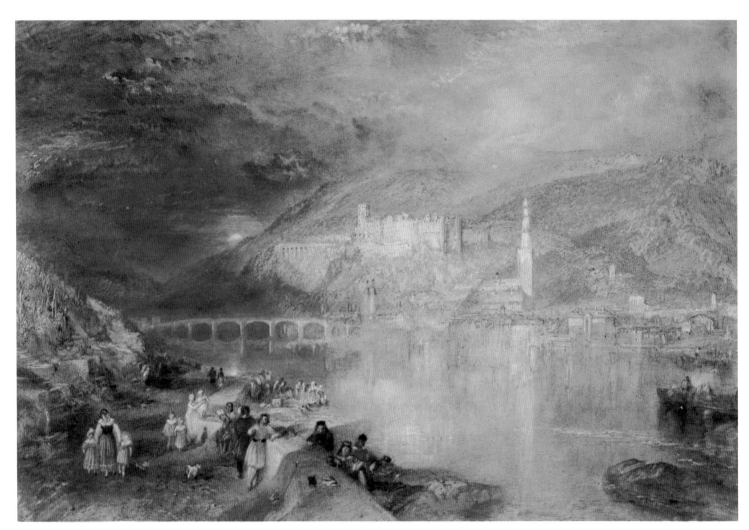

55 HEIDELBERG: SUNSET, *c.* 1841. City Art Gallery, Manchester.

57 LAKE OF THUN, *c.* 1845. The Taft Museum, Cincinnati, Ohio.

58 SION, NEAR THE SIMPLON PASS, *c.* 1843. Victoria and Albert Museum, London.

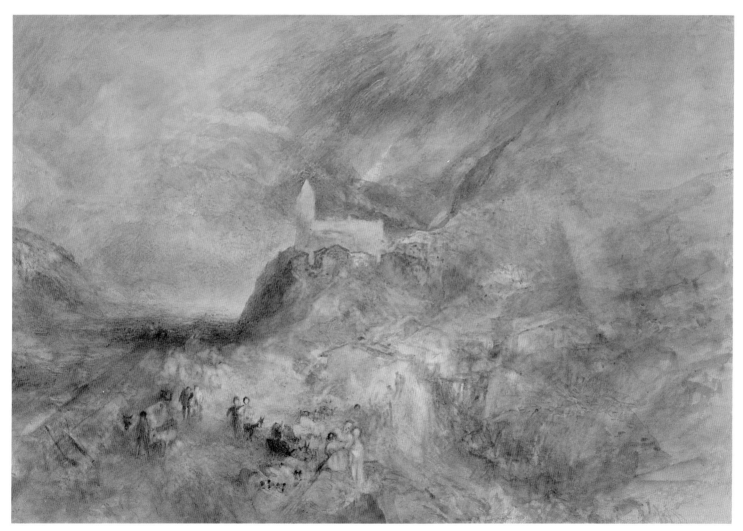

59 SION, NEAR THE SIMPLON PASS, *c.* 1845. City Art Gallery, Manchester.

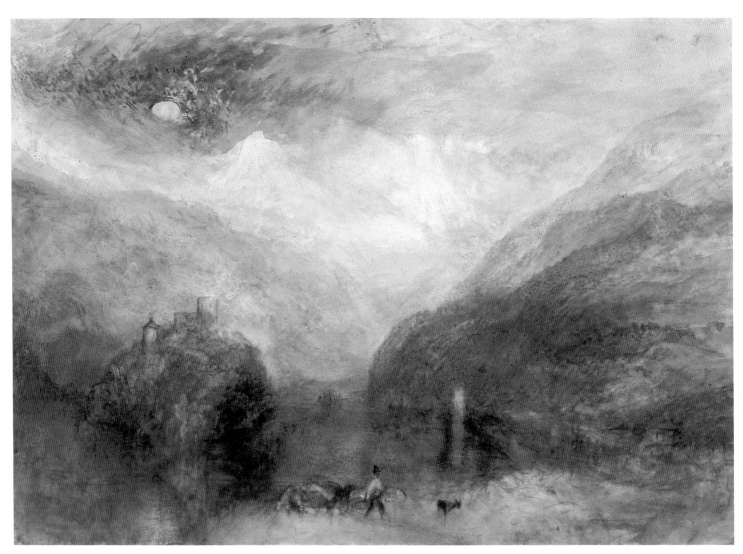

60 LAKE BRIENZ, *c*. 1846. Victoria and Albert Museum, London.

ACKNOWLEDGEMENTS:

Photographic reproductions: frontispiece, courtesy of the Royal Academy of Arts, London; ill. #1, courtesy of the Indianapolis Museum of Art, Indiana; ill. #2, 6, courtesy of the Tate Gallery, London; ill. #3, 4, courtesy of the Turner Bequest, London; ill. #5, courtesy of the Trustees, National Gallery, London; ill. #7, courtesy of the National Gallery of Wales, Cardiff; ill. #8, courtesy of the British Museum, London; entries #1, 2, 14, 15, 25, 29, 39, courtesy of the Yale Center for British Art, Paul Mellon Collection; New Haven, Connecticut; entries #3, 9, 10, 12, 19, 21, 34, 37, 43, 56, 58, 60, courtesy of the Board of Trustees of the Victoria and Albert Museum, London; entries #4, 6, 7, 11, 16, 17, 20, 23, 30, 31, 32, 33, 38, 53, permission of the Syndics of the Fitzwilliam Museum, Cambridge; entries #5, 8, 13, 18, 22, 24, 26, 36, 41, 42, 44, 48, 50, 51, 55, 59, courtesy of the City Art Gallery, Manchester; and entry #49, courtesy of Cincinnati Art Museum, Ohio.

The Taft Museum is the first Fine Arts Fund institution and gratefully acknowledges its support and that of the Ohio Arts Council.